IMAGES
of America

DENVILLE

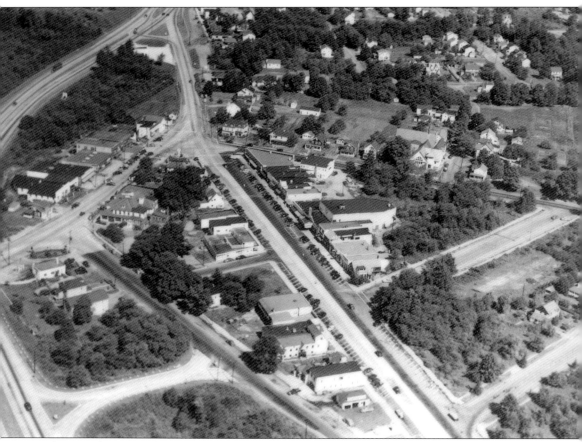

This aerial view of downtown Denville was taken on August 2, 1949. (Photograph by Henry DeWolf, DHS.)

Denville's Mayors

Denville Township was incorporated on April 14, 1913. The Denville mayors have been as follows: Frederick Eugene Parks (1913–1924), Calvin L. Lawrence (1925–1934), Joseph Hughes (1935–1941), Dr. John Gauer (1942), Phil Crowther (1943–1949), John Hogan (1950–1956), William Keefe Jr. (1957–1958), R. Gerald Wright (1959, 1962), Robert Cronk (1960), Richard Morris (1961), Howard Milligan (1963), Robert Foster (1964–1965), Jack O'Keeffe (1966, 1980–1987), Charles Muller (1967, 1969), Fred Clark (1968, 1970–1971), Robert Dalrymple (1972–1975), Walter Luger (1976–1979), Jim Dyer (1988–1995), Carol Spencer (1996–1999), and Gene Feyl (2000–).

Denville's Council Presidents

Since the change of government approved in 1971, the Denville council presidents have been as follows: Francis McCudden (1972, 1973), Earl Ferraris (1974, 1975), Richard Mohr (1976), William Barnish (1977), Mark Minter (1978, 1979), Daniel Craney (1980, 1981), Fred Lash (1982, 1983), Jack Eisenger (1984), Jim Dyer (1985, 1986), Tom Gilson (1987, 1988), Al Atkinson (1989, 1990, 1993), Roy Evans (1991, 1992), Carol Spencer (1994), Gene Feyl (1995, 1996), Vito Bianco (1997, 1998), Jim McCloskey (1999, 2000), and Pat Valva (2001).

IMAGES
of America

DENVILLE

Vito Bianco

ARCADIA

Published by Arcadia Publishing
Charleston SC, Chicago IL, Portsmouth NH, San Francisco CA

Printed in the United States of America

Library of Congress Catalog Card Number: 2001090083

For all general information contact Arcadia Publishing at:
Telephone 843-853-2070
Fax 843-853-0044
E-mail sales@arcadiapublishing.com
For customer service and orders:
Toll-Free 1-888-313-2665

Visit us on the Internet at www.arcadiapublishing.com

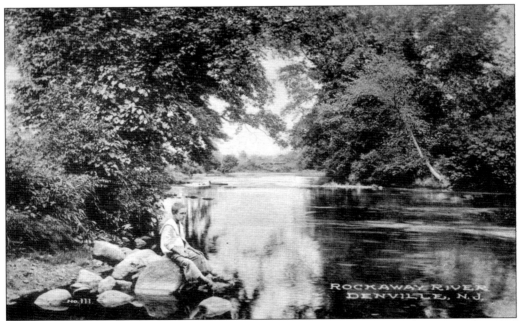

A young boy watches the gentle flowing waters of the Rockaway River on this postcard mailed from Denville just days before Denville's separation from Rockaway Township in April 1913. "Mr. Peer asked after you the first thing," the writer states, "and whether or not he should hoist the flag."

CONTENTS

This unidentified Denville gathering was held *c.* the 1940s. (Illig-Vialard Collection, DHS.)

Acknowledgments

There have been three general histories written about Denville: *Denville Days*, by Mildred L. Gill (1955); *Bridging the Years in Denville*, by Charles M. toeLear (1963); and *Reflections of Denville*, by toeLear (1988). These works have provided considerable background for *Denville*, and I am indebted to these historians for preserving Denville's past when they did and for giving me the head start they never had. I also relied on research contained in the published and unpublished works of Joseph P. Crayon, Arthur Peach, Robert Illig, Rev. James D'Angelo, and Cynthia Hinson.

I am grateful to the Denville Historical Society & Museum for its many beautiful photographs. Virtually all the images used in this publication are the property of the historical society; the abbreviation *DHS* appearing in most captions indicates that the image belongs to the society's general photograph collection. However, it would be an unforgivable oversight on my part not to acknowledge specific photograph collections within the society's inventory that have been used in this work.

First and foremost, the Illig-Vialard Collection was assembled over many years by Robert Illig and Martha Vialard. They took great care to identify most of their photographs, affording me a tremendous advantage in writing this book. The Cobb Collection, the Freeman Collection, and the Flormann Collection all deserve special recognition as well. I noted the original source of photographs within various collections and identified specific photographers when these details were known.

Finally, I want to acknowledge the recollections of Emma V. Baldwin, Bert Irish, David Cooper, Sarah Ann Fichter, J.P. Crayon, and others who thought to tell someone, jot down notes, or give interviews about early Denville life. They are all long gone, but their words and stories will live forever.

INTRODUCTION

In the days when iron ruled the Morris County economy, Denville was just one of several hamlets that dotted the northwestern reaches of Hanover Township. In the 18th century, other villages—such as Franklin and Ninkey, which were absorbed into Denville—were probably more bustling places than Denville village itself. When Rockaway Township was formed in 1844, Denville became part of it, but the tiny village was no competition with Rockaway center. Denville remained an obscure little place for some time.

Denville was not a place where great things happened—just everyday things. It was not a place where the rich and powerful lived—just ordinary people. Denville was not a town where one grand building would burn and there would be dozens more just as grand still remaining. More likely, when a Denville church or school or hotel went up in flames, so too went a little piece of every citizen, for it was probably the only one they had.

Denville did not come into its own until the early 20th century, when many people began to discover just what a charming place it had become. Its history, however ordinary, is in many ways more fascinating than that of a grander place. The town's past is made up of the everyday struggles of everyday people, rides on the canal, days in the one-room schoolhouse, and life on an ordinary farm. This is a story of those who lived life when that was not easy to do. It is a story that clearly proves just how extraordinary ordinary history can be and what a truly special place Denville is. Those who know Denville, and those learning about it for the first time, may be surprised to discover the richness of its simple heritage.

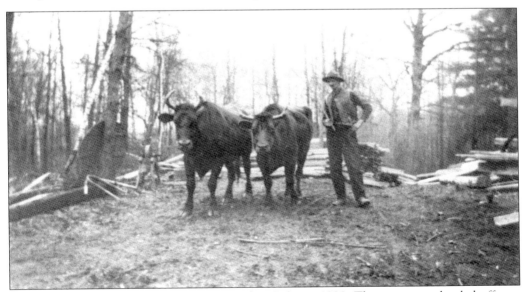

A team of oxen helps clear the land for Indian Lake in 1920. The trees were hauled off to a sawmill set up at the site. (Illig-Vialard Collection, DHS.)

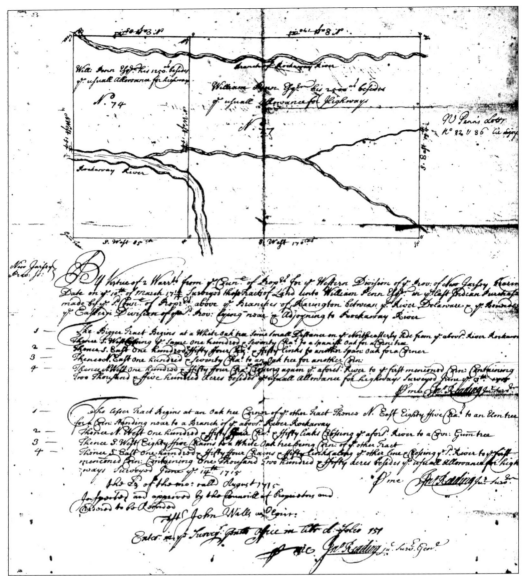

The earliest-known map of lands in Denville is William Penn's survey of lots N.74 and N.77 (1,250 and 2,500 acres, respectively). The land encompasses today's Franklin and Union Hill sections of town and continues into neighboring Randolph. The stream at the top of the survey (which is the more southerly direction) is the Den Brook, simply referred to then as a "branch of the Rockaway River." Lot N.74 is where the Cooper Road bridge now crosses the Den Brook and where the Franklin Forge operated. The top boundary line of lot N.74 is the approximate location of Hill Road today. The survey was made for Penn by the surveyor general, John Reading Jr., on June 14, 1715. The map reveals that the Rockaway River has been known by that name since at least that time.

One

HUMBLE BEGINNINGS

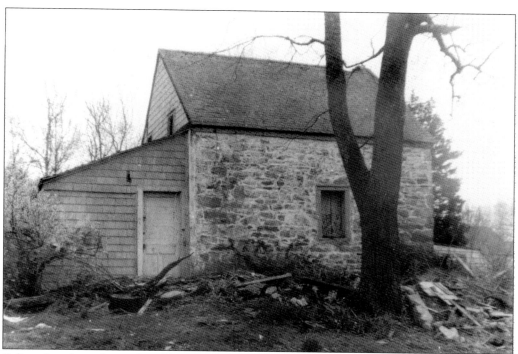

Believed to have been the oldest house in Denville, the Martin Hiler homestead was built c. 1730. It stood on the corner of Diamond Spring Road and Florence Avenue until it was razed in 1961. Martin Hiler is listed among the first settlers of Denville in Munsell's 1882 *History of Morris County, New Jersey*. Based on statements made by Martin Hiler's great-great-grandson David Smith (who was 84 years old in 1882), it can be estimated that Martin Hiler was born c. 1695. After the Civil War, this house was owned by George B. Duren and occupied by William and Sarah Cook while they were in Duren's employ. William Cook (1839–1923) was one of Denville's Civil War veterans. (Illig-Vialard Collection, DHS.)

A Den of Wild Animals

Subsequent to Columbus's discovery of land in the western hemisphere in 1492, early-16th-century explorer Giovanni da Verrazano is believed to have been the first European to have encountered the native Lenape peoples in the land that became known as New Jersey. It was about one century later when Europeans settlers came to stay. In 1609, Henry Hudson, sailing for the Dutch East India Company, ventured through the straits named for Verrazano and up the great North River that later bore his name. Dutch settlements sprang up on both sides of the river, the first in New Jersey in 1617 at Bergen, now Jersey City. The colony of New Netherlands claimed a region from New Haven, Connecticut, to Cape May and all the territory inland. Swedish colonists arrived at the mouth of the South River, or Delaware Bay, in 1638. They settled on both sides of the lower Delaware Valley, establishing the colony of New Sweden centered at Fort Christina, now Wilmington, Delaware. The Swedes soon felt the pressure of their more numerous Dutch neighbors, who had conflicting claims to the region. In 1655, New Sweden surrendered to the Dutch governor at New Amsterdam.

But Dutch rule over this vast area that now included all of New Jersey would be short lived. The English laid claim to the region as well. In 1664, a squadron of English warships entered New Amsterdam harbor. After some early resistance, the Dutch, unhappy with their governor and with the promise that they could keep their possessions, surrendered to English rule. The English king, Charles II, granted title, possession, and sovereignty of New Netherlands to his brother, James, the Duke of York (later King James II). The land and its chief city were accordingly renamed New York. The English controlled this territory for the next century, until America declared its independence.

Among his first acts as regent of New York, the duke conveyed all lands and sovereignty between the Hudson and Delaware Rivers to John Lord Berkley and Sir George Carteret. The land was known as Nova Cesaria, or New Jersey. This conveyance repaid these men for their loyalty to the monarchy during a time of great crisis in England. When King Charles I was executed in 1649, the monarchy was replaced with the commonwealth government headed by Oliver Cromwell. Despite those events, only the Isle of Jersey, home of Sir Carteret, proclaimed Charles II as king in 1649 and remained a holdout for the return of the monarchy. Charles II was restored to the throne in 1660 after Cromwell's death. The king and the duke did not forget the loyalty of Carteret and others. The naming of the new province after the Isle of Jersey honored the king's most loyal subjects. Berkley and Carteret divided the province into two parts—one called East New Jersey and the other West New Jersey.

Conflicting and rival claims to lands in the Jerseys soon began to surface. Before the English conquest of New Netherlands, English settlers from New England had already begun to populate Long Island. Some English land speculators staked claims to lands west of the Hudson River, including Daniel Denton and several other investors. Denton negotiated with the Lenapes on Staten Island for the purchase of lands in New Jersey, known as the Elizabethtown Purchase. Denton's 1664 deed came into direct conflict with the grant given to Berkley and Carteret the same year. While conflicting titles were being sorted out, Denton set out to explore his claim. If he did travel as far inland as Denville, as some have suggested, he well exceeded the bounds of the Elizabethtown Purchase, which did not extend north of Morristown, if even that far. Nonetheless, Denton's travels were published in 1670 and provided the first English-language description of New Jersey. One theory about how Denville got its name is based on the explorations of Daniel Denton. There is, however, no hard evidence that Denton explored Denville or lent his name to the area.

Berkley soon assigned all of his remaining interest in West New Jersey to Pennsylvania founder William Penn and other land speculators, known as the proprietors. Carteret's remaining

interest in East New Jersey, where Denville was later settled, was sold to Penn and others, after Cartaret's death in 1680. The proprietors surrendered their interests in both East and West New Jersey to Queen Anne in 1702. In doing so, they reserved all rights to themselves, with the exception of sovereignty, which was restored to the crown. The two provinces were united as the Royal Province of New Jersey. Lord Cornbry, already the royal governor of New York, was appointed to serve as New Jersey's governor as well. Each province, however, maintained a separate council and assembly.

It is difficult to pinpoint when European settlers began coming to Denville. One historical account suggests that the Smith family arrived in southern Denville as early as 1690. A legend that has become part of Denville's lore is that of a man named John Den. Allegedly, around the time of the Revolution, John Den lived in a log cabin where the Den Brook and the Rockaway River meet. It is from the legendary John Den that Denville and the Den Brook supposedly derived their names. However, no record of any John Den in the area has ever been found, nor is he mentioned in any early histories of Morris County.

Denville's earliest documented history comes in the form of survey maps that were prepared for William Penn and several other proprietors beginning in 1715. The abundance of iron ore in the area soon attracted prospectors. Forges in Whippany, Dover, and Morristown are among the earliest in the north Jersey highlands. Denville also had its share of early forges, since the natural ravines of the Den Brook provided much seclusion for such operations. The Den Brook forges at Ninkey, Colerain, and Franklin may date from the 1730s, according to some research. The Franklin Forge alone is documented to at least 1759.

The establishment of the Job Allen Iron Works on the Rockaway River at the Diamond Spring Road bridge c. 1730, likely marks the founding of the village of Denville. Near that site on a knoll "that juts out into the Den Meadows [by] the low swampy lands of the Den [Brook] and [Rockaway] River bottoms," wrote John Hinchman in 1800, a great number of arrowheads were found. This must have been "the basking place of all the herds of wild animals," Hinchman continued. "For lying around [the knoll] to the South West and North were many acres of Land . . . covered with an impenetrable swamp, very dense indeed, in fact," concluded Hinchman, "it was a den of wild animals, hence the name of the brook and the name of the Village of Denville." John Hinchman's letter records the oral history of Denville's elders back to 1750 and is the most likely version of how Denville got its name and its start.

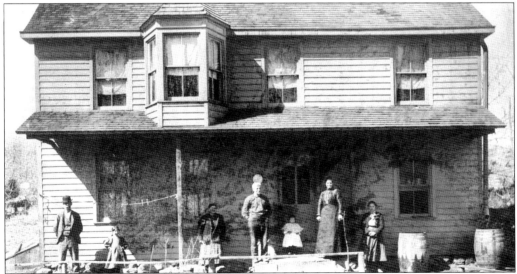

The Barton homestead on Fox Hill Road is shown c. 1898 with the Barton family on the front porch. (Illig-Vialard Collection, DHS.)

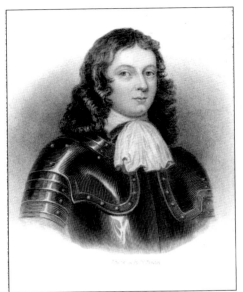

William Penn (1644–1718) was an English Quaker most noted for founding Pennsylvania in 1682. However, before he crossed to the western side of the Delaware, he and the other Quaker proprietors had purchased the rights to West New Jersey from John Lord Berkley sometime after 1674, and to East New Jersey from the estate of Sir George Carteret beginning in 1681. He began to acquire lands in Denville in 1715. The proprietors' lands in Morris County were referred to as a new "promised land," providing a place of sanctuary and refuge for fellow Quakers. After Penn's death in 1718, his two sons began to sell the Quaker lands. At that time, many Philadelphia-based Quaker families began to migrate to Morris County. A Quaker meetinghouse was erected in nearby Randolph c. 1747. The "new" meetinghouse, built in 1758, still stands on Quaker Church Road. (Engraving by W. Finden, 1838.)

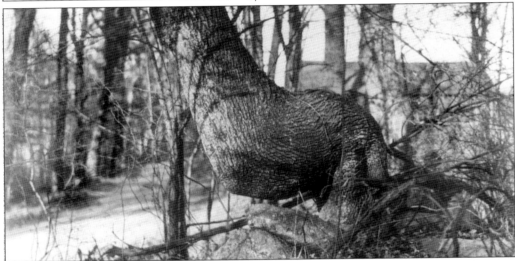

The Legend of Rock Etam in southern Denville is about three centuries old. It tells the story of two European settlers who were taken prisoner by the Lenapes for violating a hunting treaty. A Lenape princess fell in love with one of the men and, with her help, the three escaped. The Lenape chief dispatched three warriors to pursue and capture the men and return his daughter. While in flight, one of the hunters was injured. He was assisted by the others to a hilltop cave, where they rested and hid from the approaching warriors. Snows came and covered their tracks and the entrance to the cave. When the warriors arrived at the cave, no trace of the hunters or the princess could be found. Upon their return to their village, the search party reported to the chief that the "rock ate 'em." To this day, the hill and the cave of the legend are known as Rock Etam. The twisted tree shown here was discovered near Lake Openaki in 1913. The local Lenapes were known to tie saplings into this shape until a bend was established. This was done to mark their trails. A note attached to the original photograph of this tree indicated that it was "certified" as a Lenape marker by the U.S. Department of the Interior. (Courtesy of Mildred L. Gill, DHS.)

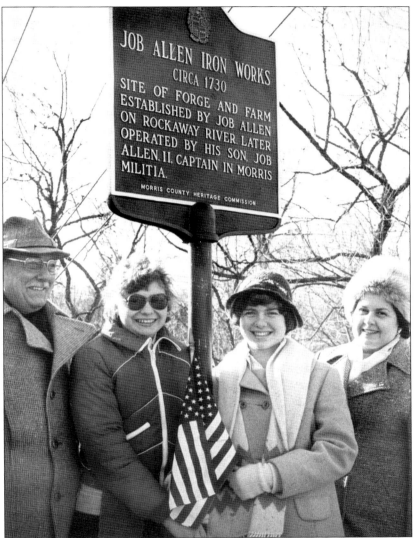

The Job Allen Iron Works was Denville's first industrial site. The town likely grew up around it soon after the forge went into operation c. 1730. The ironworks are known to have been in operation by at least 1748 from a survey of that date prepared for Col. Jacob Ford. The historical marker pictured stands along the Rockaway River side of the intersection of Pocono and Diamond Spring Roads. The first house just east of the marker on Pocono Road along the river has been identified in the Morris County Historic Sites Survey as Job Allen's house; it is one of the oldest houses in Denville, dating from c. 1740. This house is now a residence for the Sisters of the Sorrowful Mother. The house and the forge site are located on what was known as the Glover Farm, acquired by the Roman Catholic Church in 1871. The farm once included much of Lake Arrowhead, St. Clare's Hospital, Franciscan Oaks, St. Francis Health Resort, the Harvest Festival grounds, John Hinchman's "knoll . . . that juts out into the Den Meadows," and even the alleged "den of wild animals." The marker was dedicated on January 12, 1980. Shown, from left to right, are Robert Geelan, president of the Morris County Historical Society; Penny Berger; Marie Blades; and Jean Socolowski—all of the Morris County Heritage Commission. (Photograph by R. Craig for the *Daily Record,* DHS.)

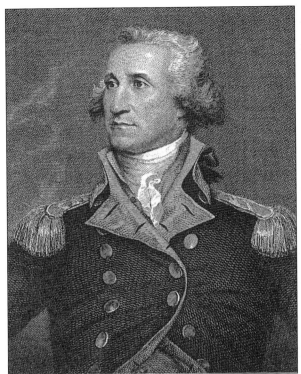

Gen. George Washington (1732–1799), commander of the American forces during the Revolutionary War, made an impromptu stop at a Union Hill blacksmith shop en route to Morristown in January 1777. He was the first of four American presidents known to visit Denville. He may have been through Denville more than once. Washington spent the winters of 1777 and 1780 in Morristown and wrote three letters from "Head Quarters, Rockaway" in June 1780. His travels through the area during the war would not have been widely publicized to ensure his safety. It is conceivable, however, that during the times he spent here, Washington periodically inspected the area iron mines and forges, such as those along the Den Brook, so vital to the American cause. (Engraving by A.B. Durand, 1834, from the painting by Trumbull.)

After back-to-back American victories at Trenton and Princeton, Washington marched northward to camp for the winter at Morristown. First, however, he headed for the iron mines at Mount Hope in Rockaway to deliver the Hessian prisoners captured in battle to Swiss ironmaster John Jacob Faesch. There, Washington was entertained at Faesch's house. Faesch, who spoke German, agreed take 250 of Washington's German-speaking prisoners. From Mount Hope, Washington marched southeast through the back roads of Denville toward Morristown. Along the way, he stopped to have his horse shod at Fordyce's Blacksmith Shop, once located in part of the old barn shown here, on the former Helliwell Farm in Union Hill. (Illig-Vialard Collection, DHS.)

14

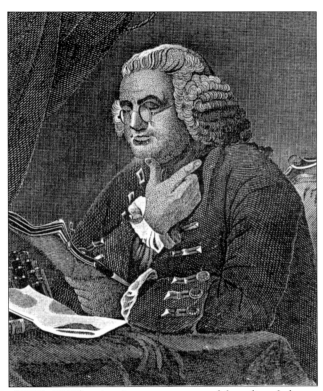

Benjamin Franklin (1706–1790), scientist, statesman, and founding father, may have had a part in Denville's early history. He was a contemporary of William Penn's two sons and of Robert Hunter Morris, all of whom had Philadelphia ties and large land holdings in Denville. These men all knew Franklin, who was evidently despised by all of them. However, an early Morris County pioneer from a prominent Philadelphia family may have called Franklin his friend. Jacob Garrigus, a former Quaker, settled at Peck Farm, just east of Denville's present border, c. 1748. At some point thereafter, the area of southern Denville, centered where Cooper Road crosses the Den Brook, became known as Franklin. Research, however, has revealed no landowners or early settlers of that name in that area. Certainly neither Morris nor the Penns would have named the area after Franklin, given their relationship. New Jersey's last royal governor, William Franklin (1762–1776), is not a likely candidate either; although he was Benjamin Franklin's illegitimate son, he opposed American independence and fled to England. Moreover, it appears that the area was known as Franklin before he had become governor.

It is speculated that Garrigus named the Franklin section of Denville after Benjamin Franklin. There is no doubt that the two men knew one another in Philadelphia and that their families were at least acquaintances. They were known to have been in each other's company at least once, at the wedding of Garrigus's brother Samuel to the daughter of Franklin's good friend James Ralph in Philadelphia in 1740. Franklin is buried in the same cemetery as Garrigus's Philadelphia family members. While no other direct connection between the men has been found, it is clear that Samuel Garrigus's family was intricately connected with Franklin for many years. Samuel named one of his sons after Franklin, and his oldest son was known to correspond with Franklin. Franklin even delivered letters from Samuel's wife, Mary, to her father in London in 1757. The community of Franklin evolved in southern Denville, centered around the Franklin Forge along the Den Brook on the land once known as Penn's lot N.74. Jacob Garrigus and his son David came to own much of the land in Franklin, including the forge. (Engraving by A. Willard, 1829.)

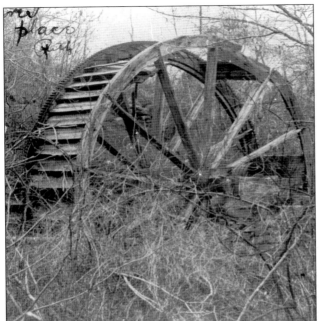

Little remains of the Colerain Forge on the Den Brook, but its name may provide a clue to its age. There was a great migration from the town of Coleraine, Ireland, to America in 1718. Passenger ship records include names such as Jackson and Ford, names known to be of early pioneer families in Morris County's iron industry. This postcard photograph (c. 1900) shows the decaying waterwheel of Clark's Paper Mill, which operated at the forge site (behind the Union School) in the 1870s. The mill was destroyed by fire c. 1875. (Illig-Vialard Collection, DHS.)

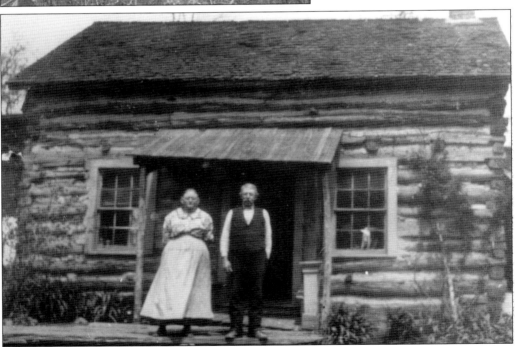

According to Sarah Ann Cooper Fichter in 1919, recalling Denville farm life before her marriage in 1849, "when anyone wanted a house built, a log house, the neighbors would all come bringing logs already cut to the right size and length, hauling them with ox teams, and in three days they would have a house built and the family living in it." This account likely explains how William and Martha Decker's homestead, shown here, was constructed. (Illig-Vialard Collection, DHS.)

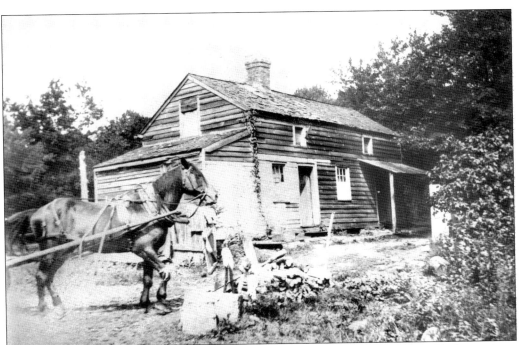

The simplicity of the Thomas Lash home attests to Denville's rugged and humble beginnings. (Illig-Vialard Collection, DHS.)

This store, believed to be the first in Denville, was originally owned and operated by early Denville settler John Hinchman. The building once stood on the corner of Diamond Spring Road where Broadway now comes through. It was part of the Hinchman Farm, but nobody seems to know what the building was used for. When the farm was sold to make way for Broadway in the late 1920s, the Hinchman family members asked that the building not be razed so it could be moved. With the help of three horses—Doll, Flora, and Nell—Emmons Freeman moved the building to the back of George Van Orden's house. (Freeman Collection, DHS.)

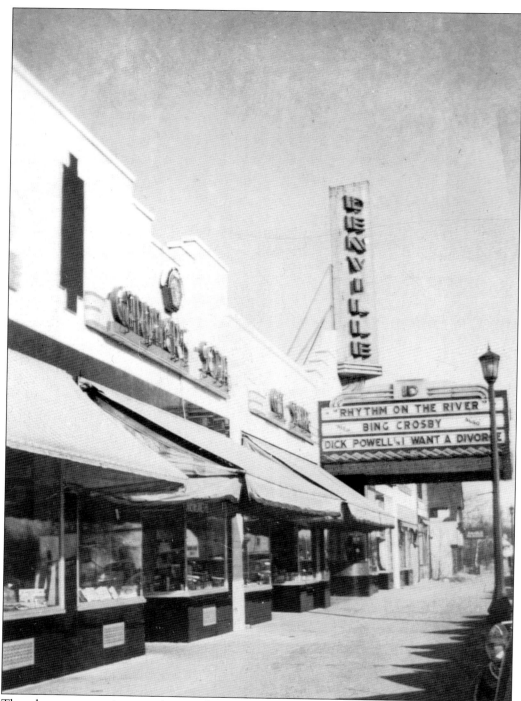

The theater marquis, complete with neon lights, became Broadway's most pronounced landmark. What was playing in Denville when this photograph was taken on February 27, 1941? Theatergoers could catch Bing Crosby in *Rhythm on the River* and Dick Powell in *I Want a Divorce*. (Illig-Vialard Collection, DHS.)

Two

BROADWAY BOUND

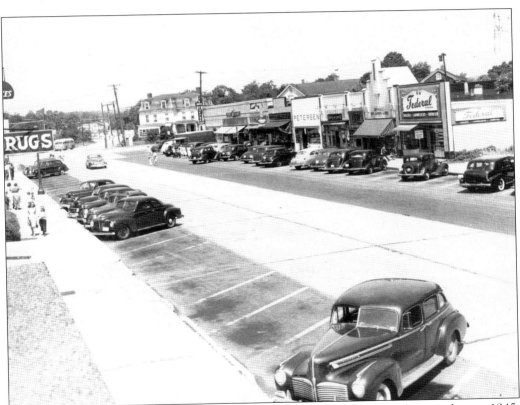

Broadway, downtown Denville, had ample parking when this photograph was taken *c.* 1945, facing west toward the intersection of Main Street and Diamond Spring Road. Shown are Federal Cleaners, Denville Dry Goods, City Cleaners, (Old) Bush's Farm Store, Petersen's Bakery, the 5 & 10, Flormann's Hardware, the A & P, Three Brothers Coffee Shop, and the old Dickerson House (where the Grand Union parking lot is today). (Photograph by P. Flormann, DHS.)

THE CHANGING FACE OF DENVILLE'S HUB

Denville village in the 18th century developed around the Job Allen Iron Works on the Rockaway River, at the Diamond Spring Road bridge. Ironworkers were among the pioneers of Denville who built the earliest homes in the vicinity of the forge. They farmed and hunted the surrounding countryside in a land still remote, wild, and quite hostile. Early Denville was a society of just a few families whose lives were centered around and dependent upon the ironworks.

People were pretty self-sufficient in those early days, but as more commerce came through Denville, so did the need for more goods and services. Many of Denville's older main roads follow the trails used by the native Lenapes or the dirt paths once used by stagecoaches. The Parsippany and Rockaway Turnpike was incorporated by the state legislature in 1809. It was part of the stagecoach line that ran through Denville's center, between Pompton Turnpike and Union Turnpike. The first hotel in Denville was soon established along the turnpike. However, iron forges and farming continued to form the basis of Denville's economy for many years to come.

The 1834 *Gazetteer of the State of New Jersey* described Denville village as "containing a store, tavern, cider distillery, and 6 or 8 dwellings." The Morris Canal came through Denville in 1831, connecting the village to the Delaware River in the west and to Jersey City in the east. The railroad came shortly after 1837, but even with these advancements in Denville, by 1842 the small village only grew to about 8 or 10 dwellings. Denville's growth continued slowly, and its image as a sleepy little village would be maintained into the early 20th century.

"Those who remember what Denville was like at the beginning of the second decade of the twentieth century," wrote local historian Emma Baldwin, "will recall that the center of town in those days had a certain charm. Denville was a quiet country village," Baldwin remembered, and contained only a few stores by 1912. Despite the widening of Main Street around that time, Baldwin recalled that "the stately old elms . . . were still standing and gave a sense of stability and dignity to the [town] center."

Most of the stores were located along Main Street and Diamond Spring Road in 1913. These stores were limited primarily to groceries and services for surrounding farmers. The village smithy, for example, with its open forge located on Main Street across from the Wayside Inn, indicated that Denville was still a country village where horses needed to be shod and farm implements repaired.

The old Denville Post Office occupied a store on the east corner of Diamond Spring Road and Main Street that later was a shoe repair shop. "The location of the town at the junction of the Main Line and the Morris & Essex Branch of the Delaware, Lackawanna, & Western Railroad had made it a convenient place of residence for those connected with the railroad," Miss Baldwin wrote. Many of them built homes near the old post office; these formed the nucleus of the town's future center.

As community lake clubs were developed between 1910 and 1930, Denville shed its country village appearance and began to attract large numbers of vacationers. Some liked Denville so much that they decided to stay year-round. Summer lake cottages were converted to all-season homes. Land developers were soon attracted to the area, offering brand-new year-round homes to former vacationers and their friends and relatives. Roads quickly became inadequate to handle the influx of people.

This growth prompted the state to build a new highway through the area. Highway 6, as it was known, generally followed the path of the old turnpike. Portions of the old road were widened and new stretches added. In 1927, the Hinchman Farm—which encompassed the entire area from the Diamond Spring Road and Main Street corner, behind the Wayside Inn, to the Rockaway River—was acquired to make way for the new highway. The Arhur Crane

Company built the new stretch of highway that veered off to the right at the Bloomfield Avenue approach to Denville and cut across the old Hinchman Farm, right through the town center. This section of Highway 6 came to be known as Broadway and forever changed the face of Denville's hub.

Broadway quickly emerged in the 1930s as Denville's new center of commerce. Before long, it became the heart and soul of the downtown as well.

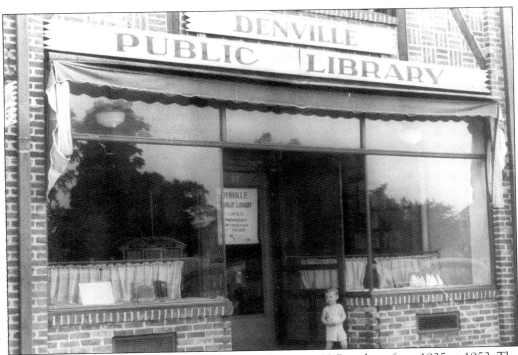

The Denville Public Library occupied this rented space at 32 Broadway from 1935 to 1952. The library's beginnings have been traced back to a circulating library in 1877 operated by the Union Sabbath School. A library was set up by the Parent-Teacher Association in a cloakroom of the four-room school on Main Street c. 1923 and became affiliated with the Morris County Free Library. The Main Street School was completed in 1924, and a classroom was made available for use as the library. The first librarian was Adaline Keeffe, who served until 1929. Angenetta Ellsworth served as librarian at both the school and then at the Broadway location until 1936. She was followed by Marian Gould, who oversaw the library's move to Diamond Spring Road in 1952. There it remained until the construction of the present library building next to the Denville Museum on Diamond Spring Road. (*The Citizen of Morris County*, DHS.)

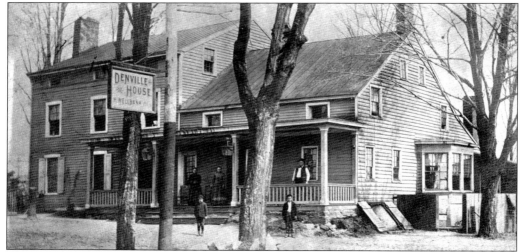

Denville's first hotel, the Denville House was established *c.* 1811. It stood at the present-day location of Summit Bank, at the intersection of Main Street and the old turnpike, now Bloomfield Avenue. It is not known for certain if the hotel was built specifically for that purpose or whether the building itself actually predates 1811. The hotel was said to have been built on the site of Stephen B. Cooper's residence by John Hinchman. However, it may have been Cooper's residence or some other existing structure, converted into the hotel. Samuel Kitchum was the first innkeeper. David Menagh later served as the hotel's proprietor for many years and was remembered as a kindhearted, obliging, and popular innkeeper. During his tenure, the hotel was generally known as the Menagh House. (Courtesy of Albert Vialard; Illig-Vialard Collection, DHS.)

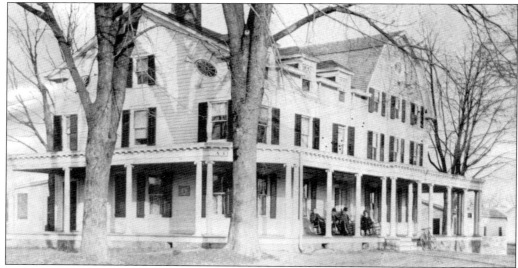

The old Denville House was operated as the new Denville Hotel after its renovation in the 1880s. The one-story right side of the old building was significantly expanded to match the three-story left side, almost doubling the size of the hotel. Dormers were added to increase light and space in the upper floors, and a contemporary Victorian porch was added. A large stable was available to maintain the horses and carriages of the hotel's patrons. The Denville Hotel burned to the ground on October 20, 1902. The hotel is shown in 1890. (Illig-Vialard Collection, DHS.)

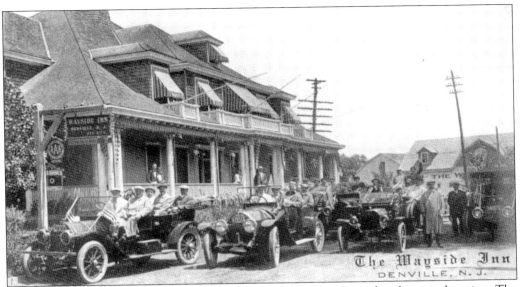

In the wake of the 1902 fire, an impressive new hotel was constructed at the same location. The grandeur of the Carmer Inn, later known and forever remembered as the Wayside Inn, became downtown's most dominant landmark for the next half century. For years, the highest vantage point in Denville center was the Wayside Inn's nearly 75-foot-high windmill and water storage tank. During the flood of 1903, it was reported that there were approximately two feet of water in the barns of the Wayside Inn. All that water would have been welcomed 50 years later when the hotel burned to the ground, the second structure on that site to do so. The Wayside Inn, shown c. 1915, was the last hotel at this location. (Illig-Vialard Collection, DHS.)

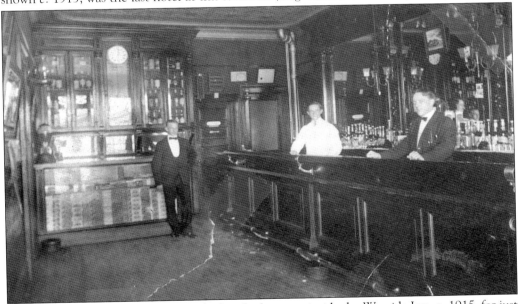

The "business men's lunch" could be had at the barroom inside the Wayside Inn, c. 1915, for just 50¢. An old advertisement for the hotel indicates that the site had been a licensed tavern since 1773. If this is accurate, it could mean that the old tavern on this site was expanded to a hotel in 1811 and had operated as a hotel and tavern since that time. (Illig-Vialard Collection, DHS.)

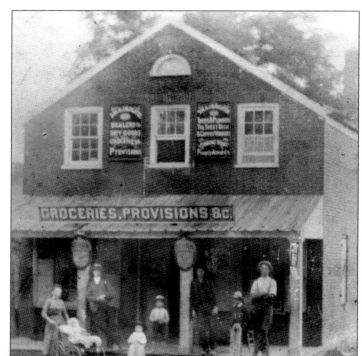

The Dickerson Grocery business, shown here before 1893, was moved from the center of town to the edge of Denville and Mount Tabor. The woman with the carriage is Amanda (Cook) Freeman, wife of Walter C. Freeman, who is standing to the right of the carriage. Their son George H. Freeman is inside the carriage. The small child nearby is Emmons Freeman, and behind him is his brother Charles W. Freeman. (Freeman Collection, DHS.)

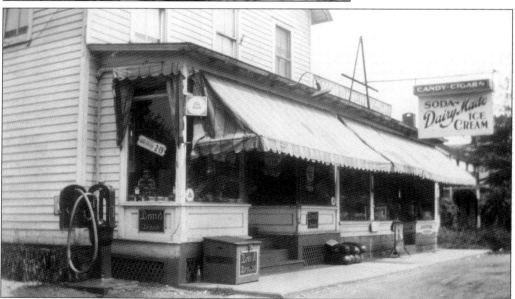

Stephen Dickerson built his home and grocery store on Diamond Spring Road, where he lived and worked until his death. In 1924, the same year as this photograph, the building was purchased by Jake Powell and operated as Powell's Market, famous for its meat. A liquor license was obtained after Prohibition in 1934. In 1944, Bulwinkle and Elder purchased the business and continued operating as Powell's Market. The liquor business was moved to Broadway in 1951. The grocery and meat business continued at the original site until 1955. (Illig-Vialard Collection, DHS.)

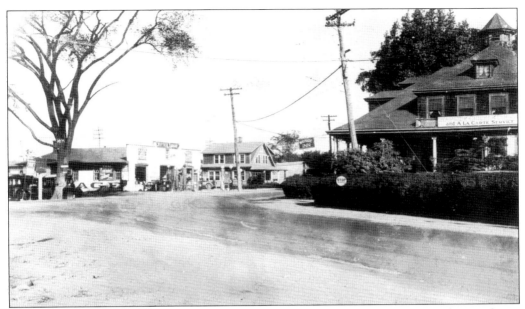

As the 1920s began, the stretch of road from the corner of Bloomfield Avenue and Main Street (shown here) and then west to Diamond Spring Road was all there was of Denville's commercial center. You could have your car serviced at the Denville Garage (center) while sampling the chicken dinner and a la carte service at the Wayside Inn (right). (Illig-Vialard Collection, DHS.)

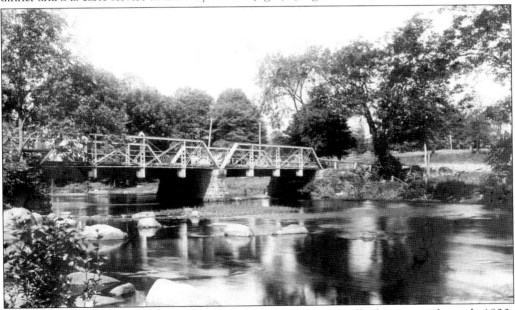

The old Rockaway River Bridge on Diamond Spring Road was still adequate in the early 1920s for the minimal traffic that approached Denville's center from the north. It was replaced in 1929 and again in 2000. It is now known as the Calvin L. Lawrence Memorial Bridge, in memory of Denville's second mayor. Prior to 1844, this river crossing connected Pequannock Township on the north side to Hanover Township on the south. The far side of the river, where the bridge meets the land, was the location of Job Allen Iron Works in 1730. (DHS.)

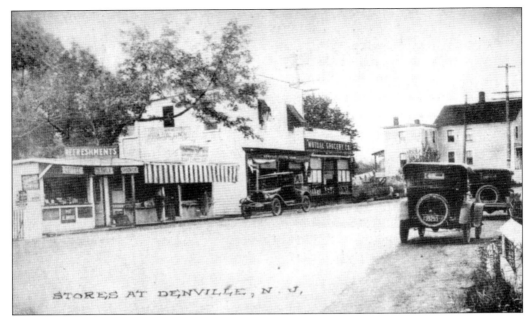

STORES AT DENVILLE, N. J,

Around the time Denville became a separate township in 1913, there were not many stores in the center of town, as is evident from this c. 1920 postcard. The only ones were those that kept a limited stock of groceries and possibly a few notions, such as the National Grocery Company, to the right of the center automobile. This is now Main Street Plaza. (Illig-Vialard Collection, DHS.)

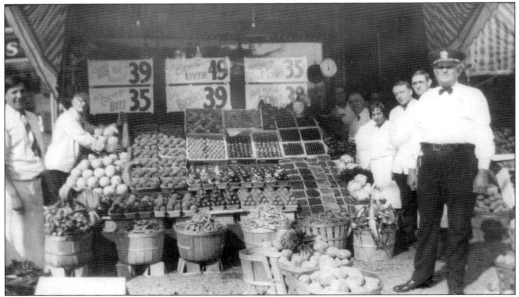

Farino's Meat, Vegetable, & Fruit Store, shown c. 1926, was located at 15 East Main Street. It sold local produce from Denville farmers such as Martin Knuth in Franklin-Union Hill. From left to right are Tony Farino, unidentified, unidentified, Charlie Lysaght, unidentified, Marie Farino, Elvin Conger, unidentified, and Chief Benjamin Kinsey. (Illig-Vialard Collection, DHS.)

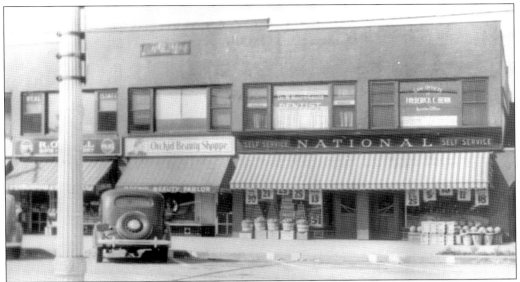

The National Grocery Company was the first self-service food market in Denville. Still at the same location as in the earlier photograph, it had been expanded, as shown in this 1938 image. The familiar shape of today's Main Street Plaza Building can still be seen. (Illig-Vialard Collection, DHS.)

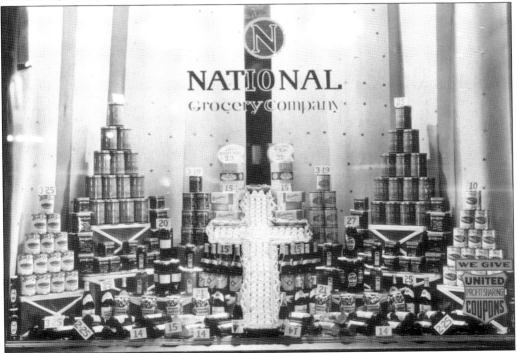

A 1938 close-up of the National Grocery Company's Easter window shows a cross made of eggs. The store was operated by Henry Kasten. No meat was sold there, but you could purchase that at the nearby Lysagt Meat Store. In January 1942, Safeway bought out the National Grocery Company. (Courtesy of Jesse Wilson; Illig-Vialard Collection, DHS.)

With the development of several lake communities in the period between 1910 and 1930, Denville became a vacation destination. The summer population of the town increased significantly, bringing a greater demand for goods and services. This photograph shows the expanding development of Indian Lake's Eastern Shore from Chestnut Hill. (Courtesy of Ted Hussa, DHS.)

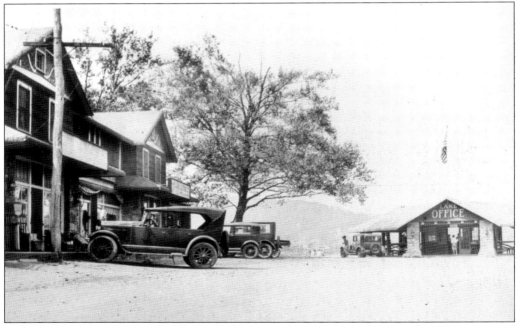

A small, commercial center at Indian Lake's main beach, shown here in the 1920s, catered to the summer residents. Indian Lake gradually evolved into a year-round community. (Illig-Vialard Collection, DHS.)

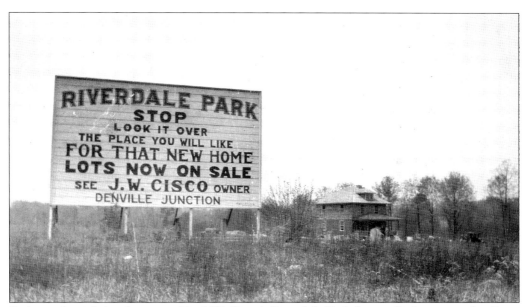

Early residential developments like J.W. Cisco's Riverdale Park (generally known as the Cisco Tract, off Route 46) began to market Denville as a year-round residence. This photograph dates from 1925. (Illig-Vialard Collection, DHS.)

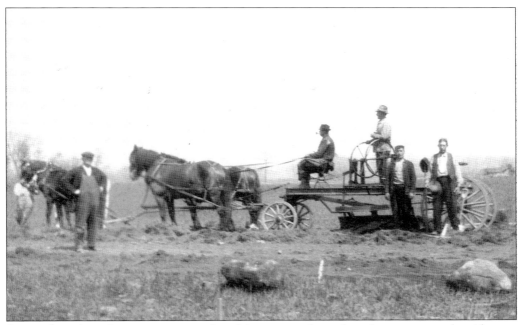

Seasonal residents began to convert their lake summer bungalows into year-round residences. Others bought new all-season homes in developments such as Riverdale Park. As Denville's year-round population grew, so did the demand on Denville's businesses to handle the new consumers. This photograph shows workmen building a street for the new homes to be built on the Cisco Tract in 1925. (Illig-Vialard Collection, DHS.)

Officer Ben Kinsey conducts traffic at the old corner in Denville's center at Diamond Spring Road and Main Street, shown here for about the last time in August 1927. Soon afterward, the town center took on an entirely new appearance. The new State Highway Route 6 (from Parsippany) cut through the old corner of Denville at a 45-degree angle and continued west toward Rockaway. The Hinchman Farm, which once stood at the old corner, was to be lost, as were the stately trees that lined the old main roads. The stretch of the new highway from the old corner east to Bloomfield Avenue became Denville's new center of commerce. The new street was called Broadway. (Illig-Vialard Collection, DHS.)

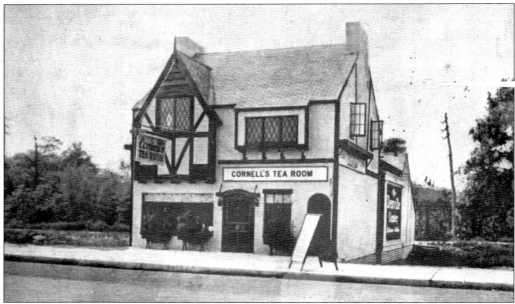

Cornell's Tea Room was the first business on Broadway in 1928. It advertised "all home cooking," and homemade crullers were its specialty. It was not long before businesses lined both sides of Broadway. (Courtesy of Mrs. Cornell, DHS.)

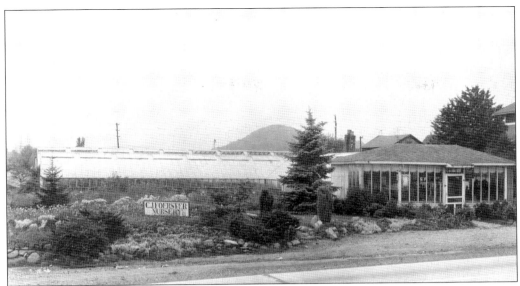

Businesses also began to spring up along the new highway just outside the town center. One new operation was the C.J. Foerster Nursery, shown here in 1932. Snake Hill can be seen in the background. Covering about four acres along old Route 6, the nursery was located where Route 80 crosses Route 46 today. The greenhouse originally contained 12,000 square feet of glass. It was reduced to half its original size in 1936. Carl Foerster ran this business with his wife, Caroline. (Illig-Vialard Collection, DHS.)

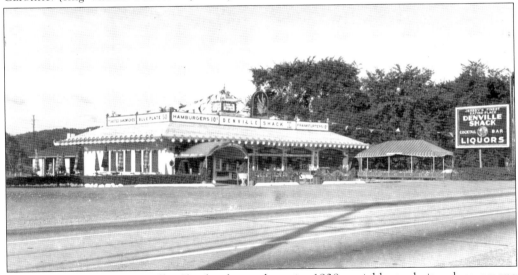

The "world-famous" Denville Shack, shown here in 1938, quickly took its place among Denville's landmarks. It was built along Route 6 in the 1920s and was located where Burger King is today on Route 46. The Shack was a Denville institution for 50 years. Initially catering to Denville's seasonal residents, the Shack became a popular attraction for everyone, particularly travelers along the highway. Patrons could feast on its 10¢ hamburgers and hot dogs or sip down a 10¢ beer. The Shack's blue plate special set you back 50¢. Salvaged by Denville Public Works foreman Steve Adams and now displayed at the Denville Museum, the flaming urn roof ornament is all that remains of the Denville Shack. (Courtesy of P. Flormann, DHS.)

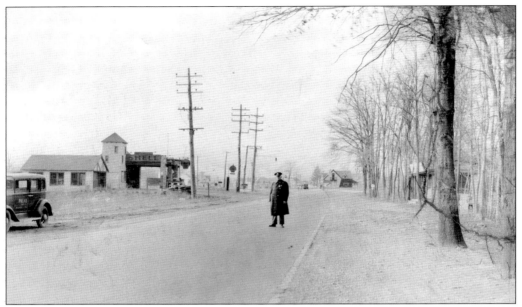

Standing out on Route 6 (now the eastern end of Bloomfield Avenue) in 1933 is Ben Kinsey, chief of police. Broadway's eastern approach can be seen over his right shoulder. The Shell station (left) was owned and operated by Jack Allen. It was the first garage in the area to do body and fender work on automobiles. Across the road was the Pantry Shelf hot dog stand (right), now the site of McCarter Park. Farther down the road was Fred Crans's store and the Fireside Tavern off in the distance. Fred Crans's real estate office was also down the road to the right. (Illig-Vialard Collection, DHS.)

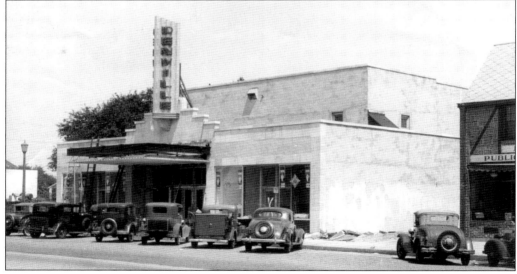

Broadway saw continued growth in the 1930s. This photograph shows the Denville Theater under construction in 1936. The theater was officially dedicated on July 21, 1937. The first movie shown there was *Parnell*, staring Clark Gable and Myrna Loy. Also shown that day were newsreels and *Our Gang* comedies. Since 1988, this has been the site of A & R Interiors. (Illig-Vialard Collection, DHS.)

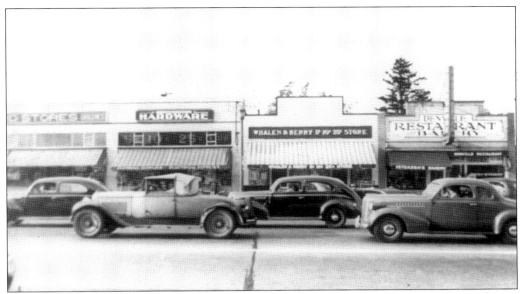

This is the north side of Broadway, near Diamond Spring Road, in 1936. From left to right are the A & P food store, Flormann Hardware, the Whalen & Berry store, Petersen's Bakery, and the Denville Restaurant. (Courtesy of P. Flormann, DHS.)

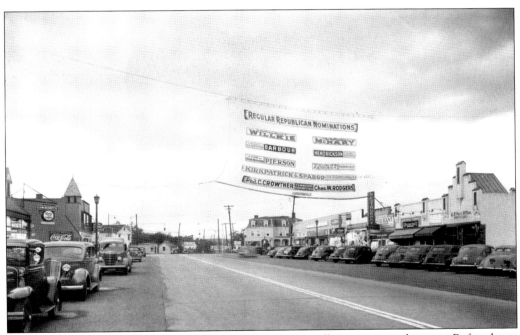

In the 1930s, Broadway had replaced Main Street as Denville's commercial center. Before long, enterprising politicians tapped into the abundance of potential voters frequenting Broadway's shops. In this image, a Republican Party banner stretching across Broadway urges potential voters to support Wendell Willkie for president and the other Republicans up for election in 1940. (Courtesy of Jesse Wilson; Illig-Vialard Collection, DHS.)

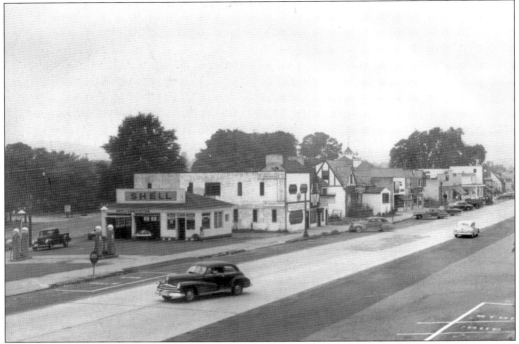

This is the south side and eastern end of Broadway in the 1940s. The Shell station is at the intersection of Bloomfield Avenue. McCalley & English Insurance is to the right, followed by Cornell's Tea Room and the Fireside Tavern. Towering above all in the distance is the ever present Wayside Inn. (Courtesy of P. Flormann, DHS.)

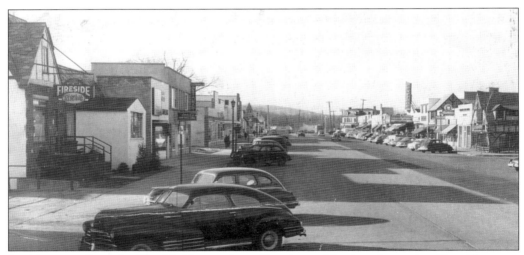

Looking west from the Fireside Tavern down Broadway, this view shows that Denville was a bustling little town in the 1940s. By the looks of this photograph, it was just as difficult to get a parking space on Broadway back then as it is today. On the right side, the whole stretch of the road from the corner of First Avenue to Diamond Spring Road was fully developed and occupied. (Courtesy of P. Flormann, DHS.)

Bob and Margaret Moore were the owners of the Denville Camera Shop on Broadway when this picture was taken in 1946 and used as a Christmas card for their customers that year. The Denville Camera Shop is still in operation at the same location today. (Illig-Vialard Collection, DHS.)

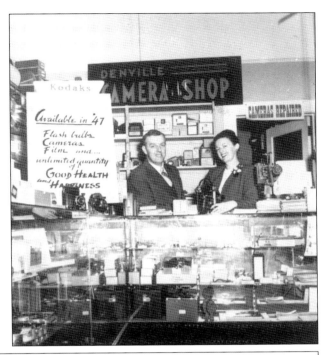

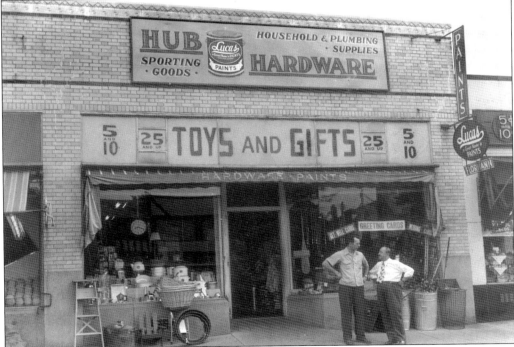

Flormann's Hardware Store, shown here, operated on Broadway from 1935 to 1947. It was also a five-and-dime store, selling all kinds of items. The shop was oddly situated right next to another five-and-dime store on Broadway, competing for the same customers. (Courtesy of P. Flormann, DHS.)

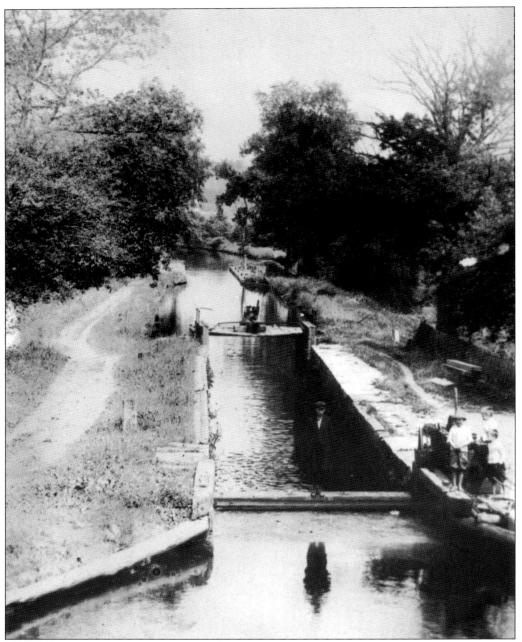

"When a boat approached, the lock tender would close the vertical doors and wickets, then lower the door at the opposite end, allowing the lock to fill to [the] level of the higher elevation. When the boat was in the lock he would raise the door at the rear of the boat. Then he would open the wickets of the doors at [the] bow end so as to lower the boat in the lock slowly. When the boat was down to the lower canal level, he would open these doors and the boat would then move out into the canal." (Bert Irish.) This c. 1900 view looks east from Peer's Lock to the aqueduct over the Rockaway River and the Rockaway Valley. (Illig-Vialard Collection, DHS.)

Three

A Canal Runs Through It

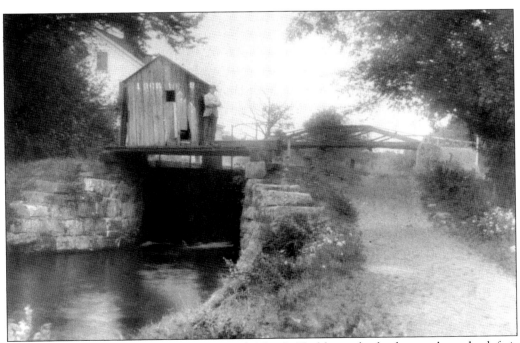

This is the western approach to Peer's Lock No. 8. Visible in the background on the left is Peer's Store. The Diamond Spring Road bridge over the canal is in the center, and the towpath crossing under the road is to the right. The postcard is from the early 1900s. (Illig-Vialard Collection, DHS.)

Life on the Morris Canal

George P. Macculloch of Morristown conceived of the concept of a canal connecting the Delaware River to Jersey City while he was on a fishing trip at Lake Hopatcong. He believed that increasing the lake's water retention by damming its outlet, given the lake's high elevation, would supply an amount of water capable of supporting a canal system that flowed in both an easterly and westerly direction across northern New Jersey. Macculloch further believed that the need to transport mineral products and iron so abundant throughout the region would make the project economically feasible. While the concept sounded good in theory, there was still a question as to whether it would work.

Macculloch first tried to sell his idea to the state. He succeeded in getting the legislature to appoint an exploratory committee in 1822, but that proved to be the extent of the state's interest. After the committee rendered its report the following year, the legislature refused to commit to the project.

Still determined to bring his concept to fruition, Macculloch turned to the private sector. Eager investors raised $1 million in capital, and the Morris Canal and Banking Company was incorporated on the last day of 1824. Maj. Ephraim Beach selected the canal's route and oversaw its construction. The plans called for the canal to pass just north of the tiny village of Denville. By 1831, the stretch from Easton, Pennsylvania, to Newark was completed. The last stretch to Jersey City was completed in 1836. Overall, the canal would cover more than 102 miles, climbing to a maximum elevation of 925 feet above sea level at Lake Hopatcong. The total cost of the project was $2 million.

"Along the entire route of the canal there were several 'locks' and 'planes,'" wrote Denville canal traveler Bert Irish. "These were necessary because of the variation in ground levels. Locks were built where . . . variations were around twelve feet or so," he recalled, "and planes were built where [the] variation was greater."

Lock No. 8 was located in Denville just east of Diamond Spring Road. This lock became known as Peer's Lock because of the store situated alongside of it, owned and operated by Edward C. Peer and his family. There were no planes in Denville, but the one in neighboring Rockaway was the first one completed along the entire canal route. Planes were used to raise and lower canal boats with cables across land, between two elevations deviating more than 12 feet. This was a new concept in canal engineering in those days, and planes were used for the first time anywhere on the construction of the Morris Canal. There were inevitably many problems with the operation of the planes from the beginning. Adjustments had to be made after much trial and error and at considerable expense, but the problems with the planes were never fully solved.

When approaching the lock, the canal boat captain would sound a horn so that the lock tender knew to start the lock system in operation. The boats were pulled with ropes by mule teams along the towpath, sometimes guided by the captain's assistant. Mules were fed and rested in mule barns that could be found along the length of the canal. There was a mule barn in Denville at Peer's Lock. Mules often developed wounds from pulling the boats. Lock tenders regularly traded healthy mules with injured ones, giving the injured mules time to heal before going back on the towpath. Laws were passed establishing fines to protect the mules from abuse.

There were bridges over the canal at Diamond Spring Road, Savage Road, Cedar Lake Road, and Morris Avenue. Below Peer's Lock, the canal passed over the Rockaway through an aqueduct. Denville's canal basin was located near Savage Road. "A basin," Bert Irish explained, "was a space dug out of the side of the canal so a boat would be out of the way and allow other boats to pass." Both the basin and the aqueduct were popular swimming holes in summertime. When the canal froze in winter, it was used for ice-skating.

The canal proved to be more picturesque than profitable. The initial investors could not repay loans to cover construction over-costs and were forced to sell in 1844. The new owner continued to operate under the same name but with no fewer problems. Competition from the railroads became the biggest threat to the canal's survival. After 1837, the Morris & Essex Railroad, already in operation, was extended through Denville to Dover. In 1866, the railroad was extended all the way to Phillipsburg and began transporting coal in direct competition with the canal. A trip across the state that took five days on the canal only took eight hours by train. Problems with plane operation persisted, and water loss from animal holes dug in the berm bank and towpath became another serious issue.

Despite all the setbacks, the Morris Canal will forever be part of Denville's charmed past. In Denville, historic markers and romantic images are all that remain now of the tranquil Morris Canal that crossed the scenic hills and valleys of northern New Jersey. Denville can at least be counted as one of those special places where once a canal ran through it.

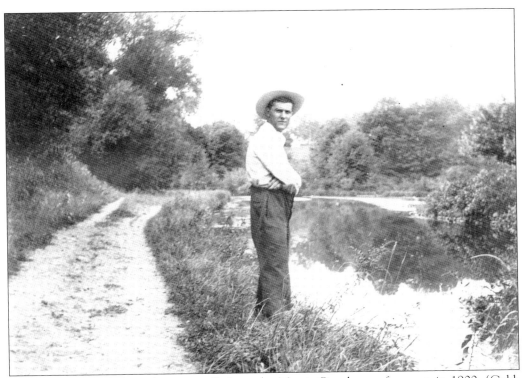

Leonard Cobb is shown taking a stroll along the Morris Canal one afternoon in 1900. (Cobb Collection, DHS.)

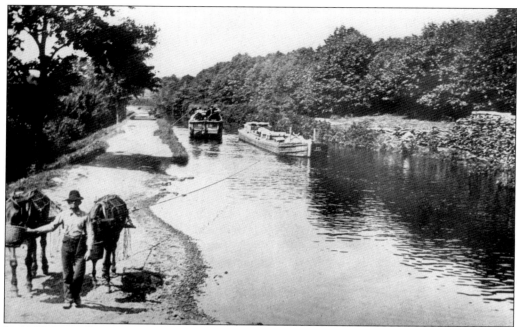

In 1955, Denville resident Bert Irish recalled his trip along the Morris Canal c. 1905 in a letter to local historian Mildred Gill. "The canal boats were drawn by two ropes attached to a pair of mules. At times it was necessary for the boat operator's helper to walk along with the mules, especially at points where there were 'locks' and 'planes.'" The photograph shows two mules pulling a canal boat westward, near the lumberyard by the Savage Road bridge. It was the main lumberyard for this section of the country. (Illig-Vialard Collection, DHS.)

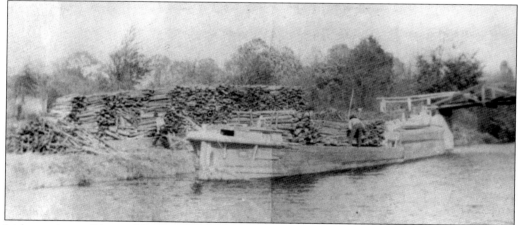

Irish continues: "A canal boat man by the name of Bill McCollick invited me to go along with him. At the time he had a load of coal to be delivered to a factory at Orange Street, Newark, N.J. The cargo was loaded at . . . Phillipsburg, N.J. on the Delaware River. I went aboard with Bill at Ed Peer's lock. . . . As I recall, between Denville and Newark, we 'hooked up' for the night at Paterson, N.J., in one of several 'basins' along the route. . . . We arrived in Newark the next day and unloaded the coal [and then] started back to Phillipsburg for another load." All kinds of goods were shipped along the Morris Canal. This photograph shows a canal boat loading up cordwood in the Denville basin below the Savage Road bridge. (Illig-Vialard Collection, DHS.)

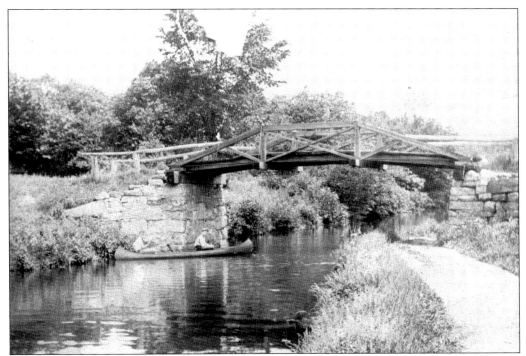

Bert Irish's narrative continues, "When we reached Denville I had completed a round trip which took ten days and covered approximately 150 miles . . . through some very nice country and farm areas." The photograph shows the approach along the towpath to the Savage Road bridge over the canal facing west. (Illig-Vialard Collection, DHS.)

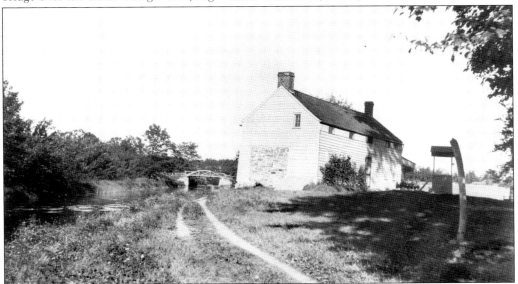

The Canal House, on Morris Avenue, was reputed to be one of the stations on the Underground Railroad, where escaped slaves from the South stayed by day as they moved north toward Canada by night. In this c. 1909 view of the Canal House, the Cedar Lake Road bridge over the canal can be seen in the distance. (Courtesy of Raymond Righter, DHS.)

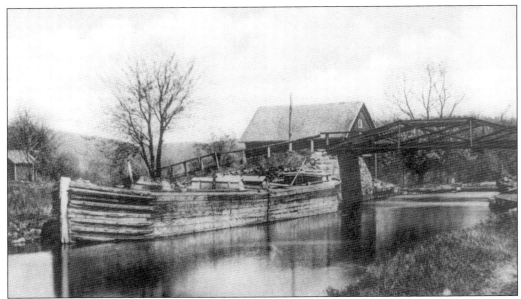

More of Bert Irish's account reads: "Boats were made in two sections and fastened together by hinges similar in a way to the coupling method of railroad cars. . . . By building the boats in two sections it was possible to turn each section in the opposite direction for a return trip due to the [narrow] width of the canal." This postcard shows a canal boat just west of the Diamond Spring Road bridge, at Peer's Lock. (Illig-Vialard Collection, DHS.)

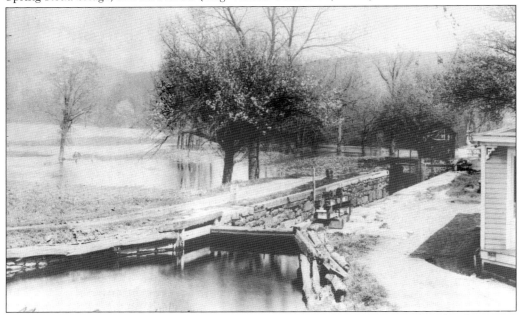

Irish continues: "Locks were built where ground level variations were around twelve feet or so, as I recall. [With] locks, it was necessary to close a pair of doors having wickets which was an opening and closing arrangement at [the] bottom edge of [the] doors. At the opposite end of the lock was a door hinged at the bottom that was raised and lowered by a chain and gears." This postcard of Peer's Lock is postmarked April 13, 1911. (Illig-Vialard Collection, DHS.)

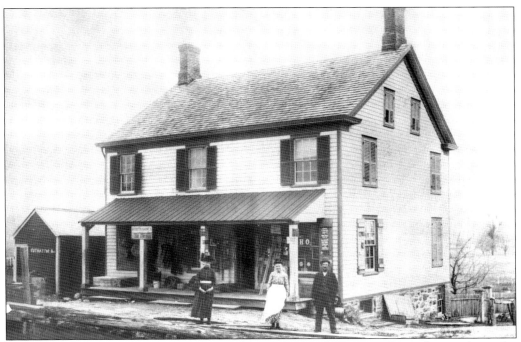

This view of Peer's Store, probably taken during the Civil War era, shows the porch on the canal side of the building. The man to the right is Edward C. Peer, the proprietor. In the middle is his wife, Sarah Louise Peer. (Illig-Vialard Collection, DHS.)

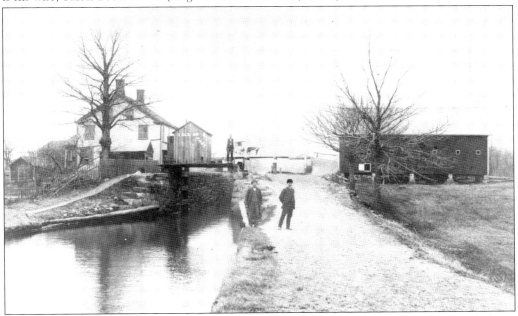

Bert Irish's narrative continues, "The side or bank of the canal where the mules traveled was called the towpath and the opposite side, the berm bank." This photograph shows a rear view of Peer's Store (left), facing west toward the lock. On the right is the original mule barn. The photograph was taken prior to 1880. (Illig-Vialard Collection, DHS.)

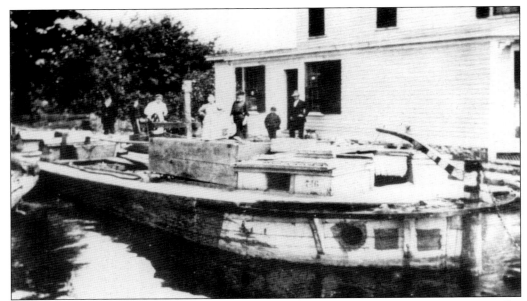

Bert Irish's account of travel along the canal continues: "At the rear of the boat was a tiller rudder to control the bow direction of the boat. . . . At the rear of the second section we went down the steps to the bank." This photograph shows canal boat No. 746 in the lock at Peer's Store. Notice that the open porch from earlier photographs was enclosed by the early 1900s. (Illig-Vialard Collection, DHS.)

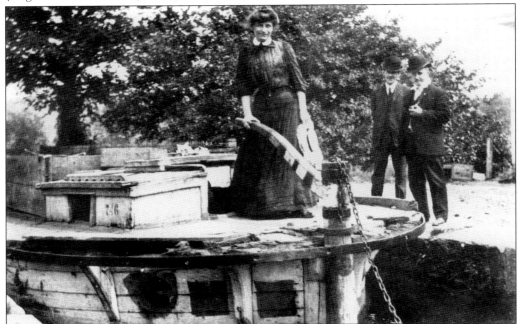

Irish continues: "Our meals were cooked on an open cylindrical stove on legs on the deck. Above the coal bunkers along the side edges of the boat, was a narrow walk from stern to bow. We washed out clothes and bathed in canal water." This c. 1900 photograph captures the arrival of canal boat No. 746 at Peer's Lock. (Illig-Vialard Collection, DHS.)

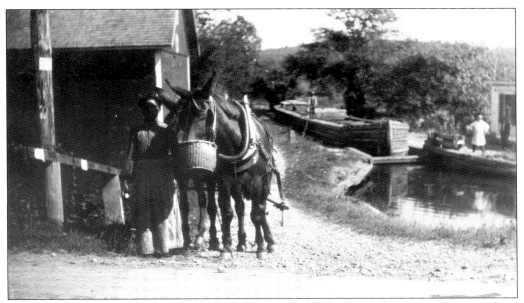

The narrative of Bert Irish continues: "The boat operators had specific towns or places where they intended to stop for the night. At these points there were barns to house the mules and a fee was charged for their feed and bedding down." In this 1880s view, an African American woman tends to the mule team at Peer's Lock mule barn. (Courtesy of H.E. Barnes; Illig-Vialard Collection, DHS.)

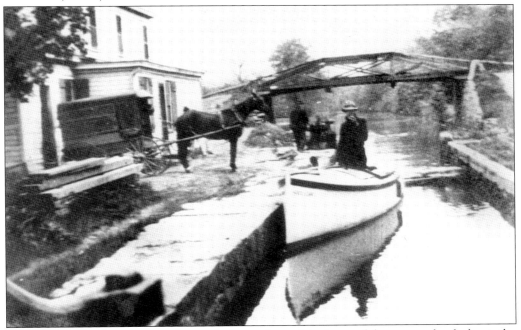

Irish continues: "In order that the . . . locks tenders might learn of the approach of a boat, the 'captain' would blow on a shell type horn. This sound could be heard for quite a distance, giving the tender ample time to prepare the locks . . . for the boat." Peer's delivery wagon awaits the arrival of a shipment along the canal c. 1900. (Illig-Vialard Collection, DHS.)

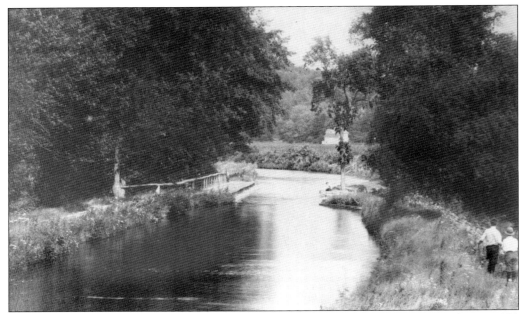

A closer look of the flat and fertile land of the Rockaway Valley can be seen in this *c.* 1900 photograph of the canal below Peer's Store, heading east toward the Rockaway River aqueduct. From this point, the canal followed a relatively even course through the valley, until it came to the head of the Rockaway Falls at Boonton. (Illig-Vialard Collection, DHS.)

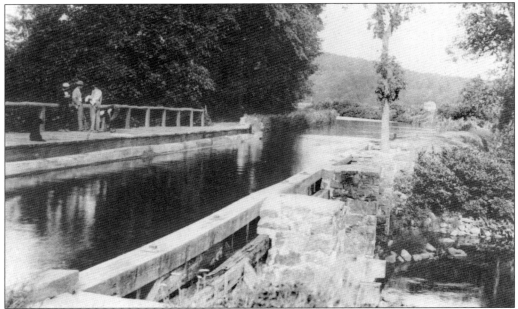

Bert Irish's account concludes: "There is one more physical detail concerning the course of the water in the canal and that is the aqueduct. This is a wooden trough-like section which water flows through when the canal crosses over [a] river, stream, etc. which is at a level below [the] canal level." This *c.* 1900 photograph shows a close-up of the canal aqueduct over the Rockaway River. (Illig-Vialard Collection, DHS.)

Four

FROM HERE TO THERE

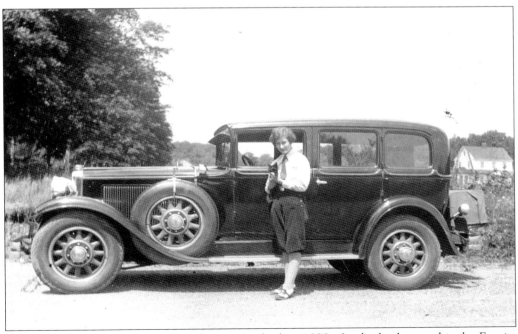

Emmie Hyam poses in front of her first car in the late 1920s. In the background is the Everitt Vanderhoof house. (Illig-Vialard Collection, DHS.)

Planes, Trains, and Automobiles

Getting from here to there in Denville, as elsewhere, has changed dramatically through the years. The native Lenapes traveled on foot over ancient trails. The most notable of these was the Minisink Trail, which roughly followed the same course as Route 10 today, passing through southern Denville. Early explorers into New Jersey's interior, such as Daniel Denton, likely followed this trail, as did those who came to settle in the area.

As the area that became New Jersey developed and the population grew, the old trails became inadequate to get people from here to there. Horses were the fastest means of transportation in the early 19th century, and good roads were needed to accommodate stagecoaches. A system of turnpikes and toll roads was developed, generally following the paths of the old foot trails. The Parsippany and Rockaway Turnpike passed through the center of Denville, and part of the old Mount Pleasant Turnpike still crosses southern Denville today. Horse travel along dirt and gravel roadways was the predominant way to get around these parts well into the 20th century.

The Morris Canal was operating through Denville in 1831. Except for accounts of smuggling runaway slaves to freedom, or the occasional teenager who would hop aboard a canal boat for an adventure, the Morris Canal generally transported goods and materials, not people. The average person still relied on his horse to get from one place to another. In freight transportation, however, the canal enjoyed about six years with little competition. That was, of course, before the railroad came through Morris County in the years after 1837. Ephraim Beach was again called upon to select the route for the railroad extensions from Morristown to Boonton and Dover, as he did with the canal route several years earlier. Denville was again included in his plan and became a junction for the new northern and southern branches.

The railroad continued to expand through the 19th century but, by century's end, faced competition (at least in transporting people) from trolleys. The popularity of trolleys quickly spread through Morris County, and trolley lines began appearing in the first decade of the 20th century. The trolley lines to Boonton and Morristown debuted in Denville by the fall of 1909. In less than 20 years, however, trolley service was discontinued and buses took over the business of transporting people.

Horses, too, soon fell from grace due to the speed, affordability, and independence of the automobile. Trips that once took days now took only hours in the automobile. Travel was no longer dictated by a schedule but, rather, by personal preference. You could come and go as you like. With the automobile, a whole service industry was developed to keep the cars in good repair and ready to go. The Denville Garage and other service stations began to appear on Main Street and Bloomfield Avenue. Denville's downtown started to experience a couple of problems it never had before—traffic and parking.

As the number of automobiles increased, the roadways needed to be expanded and improved. Old dirt roads were paved and widened to make for a smoother and safer ride. Highways were constructed through Denville in the 1920s and 1930s and were expanded to multilanes in the decades that followed. By the 1950s, the concept of interstate highways caught on in America. Route 80 was planned to pass right through the center of town just as the canal and the railroad had done before it.

The bicycle had gained in popularity in the late 19th century, but it was no competition for the automobile. On the steep hills and in the deep valleys of northern New Jersey, the bicycle proved more recreational than practical. Air travel began in the early 1900s but did not begin regular passenger service for many years. Some people in Denville even had their own airplane. By today's standards, this would still be considered a luxury. Denville has had a heliport on Palmer Road since 1983. There is no airport in Denville, but the noise caused by air traffic

from nearby Newark and Morristown Airports has been a topic of concern for some Denville residents in recent years.

No matter how they traveled—on canal boats, horses, trolleys, and bikes or in planes, trains, and automobiles—Denville folks always managed to find a way to get from here to there.

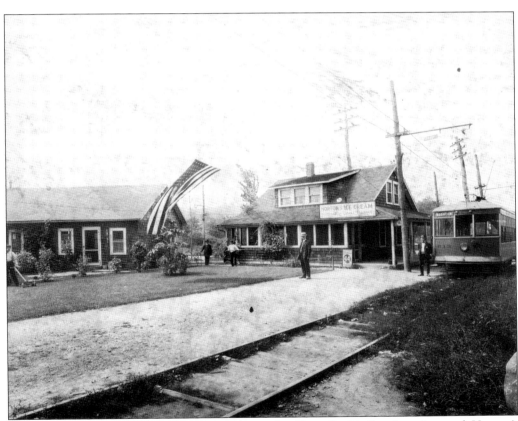

The above photograph, taken in 1917, shows the Denville Trolley Junction and Horton's Ice Cream Parlor, owned and operated by Joseph W. Cisco. Travelers changed trolleys at this point to go either to Boonton or to Morristown. The trolley in the photograph is headed for Boonton. (DHS.)

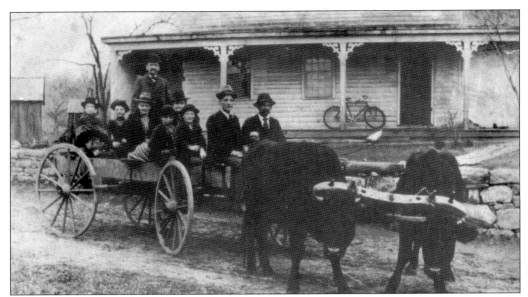

After Thanksgiving dinner in 1903, the Freeman family went for a little ride in this oxcart. The Freeman homestead at Morris Avenue and Savage Road appears in the background. (Freeman Collection, DHS.)

A horse-drawn carriage approaches Denville center along Main Street (Route 53). This photograph was taken from an upper floor of the Wayside Inn c. 1907. In the background is Chestnut Hill, and below it is the site of today's A & P shopping center. The building to the left is Ford's Blacksmith Shop, and behind it is John H. Hall's house. The barns on the right belong to Bill Green. The tracks in the foreground are the trolley line to Boonton. The far tracks are the trolley line to Morristown. The road sign advertises, "ROAD MAP FREE / THE WAYSIDE INN / RESTAURANT & GRILL." (Courtesy of William T. Greenberg; Illig-Vialard Collection, DHS.)

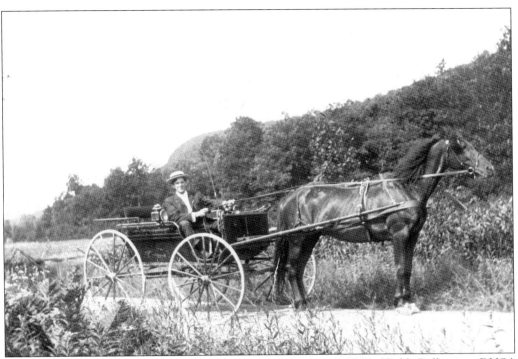

Nelson Cobb takes a ride into town with his horse and buggy c. 1900. (Cobb Collection, DHS.)

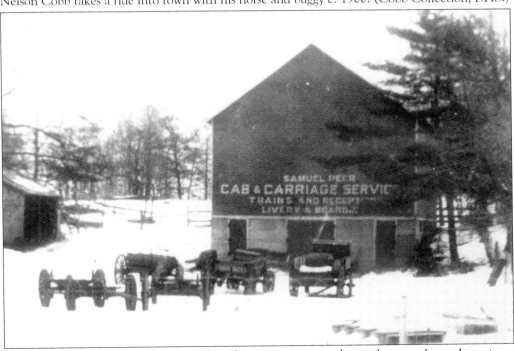

Long before automobile service stations became necessary, horse-drawn cabs and carriages needed servicing. In Denville, that was the job of Samuel Peer. His Cab & Carriage Service barn was located on Diamond Spring Road across from his house. (DHS.)

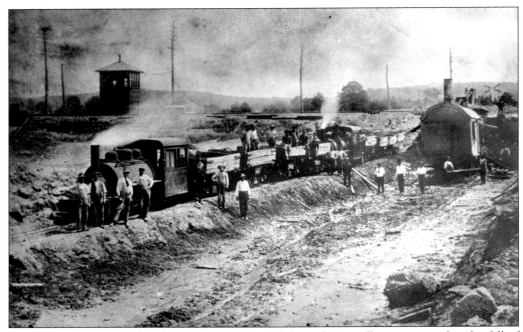

The Morris & Essex Railroad tracks were extended through Denville sometime after the fall of 1837. The Morris & Essex Railroad was absorbed by the Lackawanna Railroad in 1868. In 1910, it was decided to make major improvements between Dover and Hoboken on the Morristown Line. The several-year project eliminated most of the grade crossings in Denville. This *c.* 1915 photograph shows the railroad improvements under construction. (Freeman Collection, DHS.)

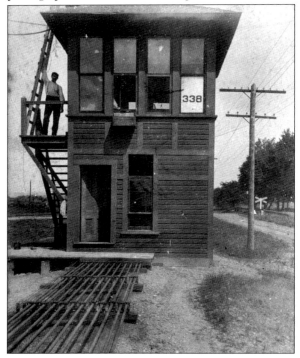

The old Denville railroad tower, built before 1903, was relocated that year to the wye junction of the Boonton and Morristown branches. Shown standing on the tower is Stewart Peer. (DHS.)

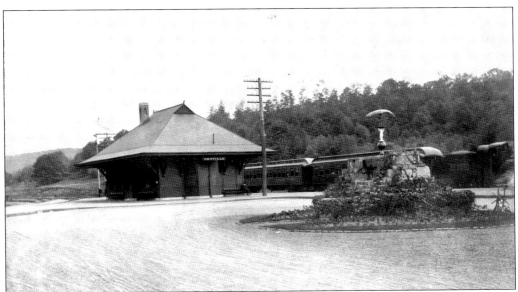

The "new" Denville railroad station was built in 1903. The original station, built in the 1840s, was located along Route 53 where the Einhorn Harris law offices are now located. There was an effort to save the 1903 station from demolition in the early 1990s. Unfortunately the cause never really caught on, and the Denville station was torn down later that decade. (Freeman Collection, DHS.)

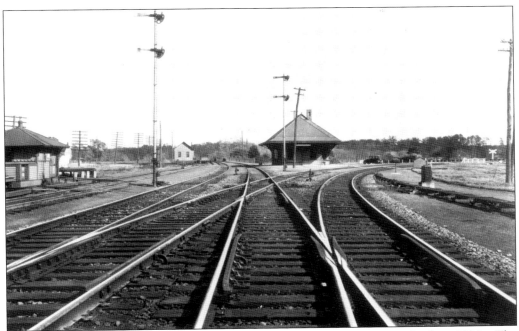

This was the approach to the Denville railroad station from Dover in the late 1920s. The Morristown branch is to the right and the Boonton branch to the left. The building in the left foreground is the baggage building. (Courtesy of the Railroad Museum of Pennsylvania [PHMC]; Illig-Vialard Collection, DHS.)

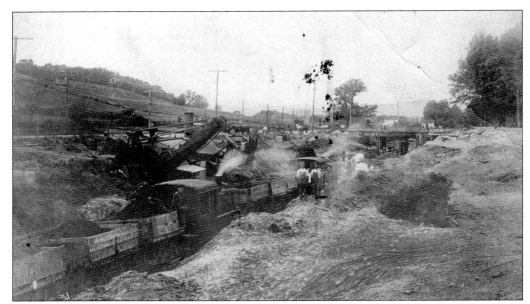

The Morris County Traction Company was incorporated on June 13, 1899, to construct a trolley line from Wharton to Dover, through Rockaway and Denville, to points east. By the end of 1909, the line was operating from Morristown to Wharton. During construction through Denville, it was determined that two underpasses needed to be constructed. The above photograph is believed to show the excavation of one of the trolley tunnels. (Illig-Vialard Collection, DHS.)

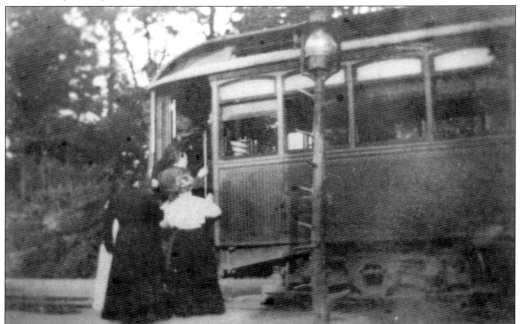

Some local women board the trolley at Denville for a ride on October 10, 1910. Among the "trolley party" are Mrs. Peter Freeman, Mrs. E. Davenport, Mrs. W.A. Deares, Nettie Freeman, and Mrs. A.B. Davenport. (Illig-Vialard Collection, DHS.)

For some, bicycles are as popular today as they were when Emmons Freeman was photographed in the 1920s. Freeman posed on the Savage Road bridge over the Rockaway River. His bike required good old-fashioned leg power. There were no multigeared bikes back then. (Illig-Vialard Collection, DHS.)

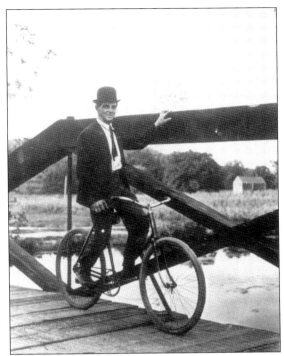

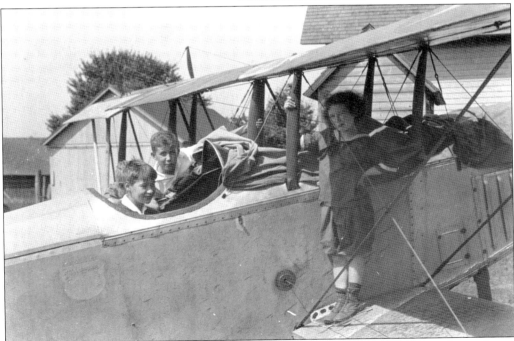

Some Denville folks even had their own airplane to get around. The Jenny plane, shown c. 1920, belonged to Arthur D. Crane. The children in the photograph are, from left to right, Joseph Nevin Jr., Arthur D. Crane, and Kathleen Nevin. A fourth child behind Joseph Nevin is unidentified. (Illig-Vialard Collection, DHS.)

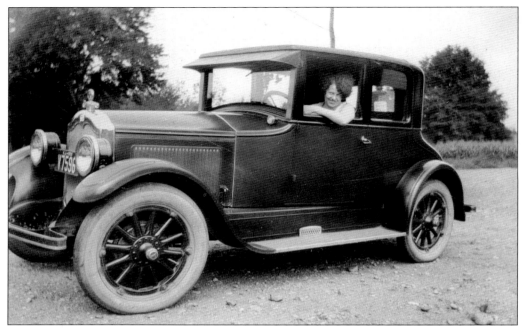

Soon, fast and convenient automobiles replaced older forms of transportation. Helen L. Peer rides in the family Buick in July 1926. (Illig-Vialard Collection, DHS.)

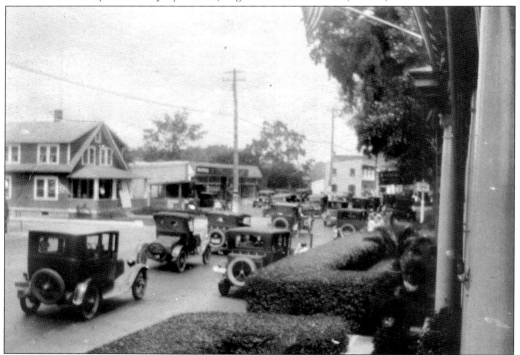

It was not long before Denville began to experience a new phenomenon known as traffic jams. This photograph shows a heavy traffic day on Main Street in front of the Wayside Inn in the 1920s. (Illig-Vialard Collection, DHS.)

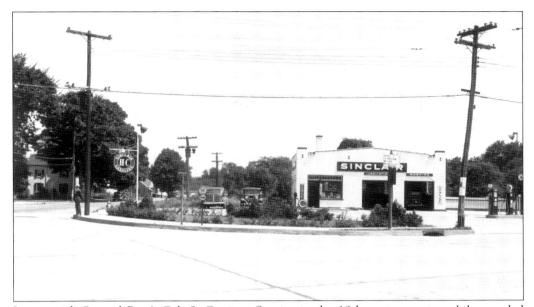

Just as with Samuel Peer's Cab & Carriage Service in the 19th century, automobiles needed service too. Soon, service stations for gasoline and automotive repair would begin to pop up along the highways. The Sinclair station at Bloomfield Avenue and Main Street (Route 53), shown in the 1930s, is now the site of McCarter's Garage. (Courtesy of Jesse Wilson; Illig-Vialard Collection, DHS.)

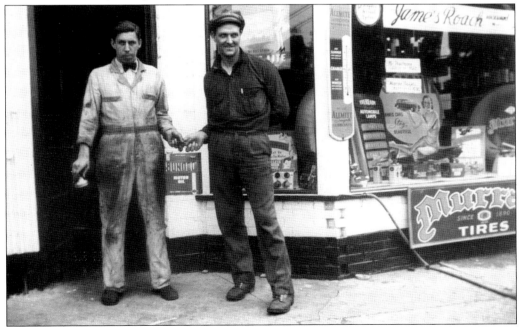

The Tydol station, shown c. 1938, once operated where Denville's senior citizens building is today. Mr. Zecca, the owner, would put the names of customers who owed him money in the window for all to see until the bill was paid. Servicemen Rus McCurdy and Slim Ackerman were on hand to take care of the customers. (Illig-Vialard Collection, DHS.)

Leonard Cobb and his mule were photographed at the barn on the Cobb Farm *c.* 1900. (Cobb Collection, DHS.)

Nelson Cobb is out in the pastures on his farm *c.* 1900. (Cobb Collection, DHS.)

Five

DOWN ON THE FARM

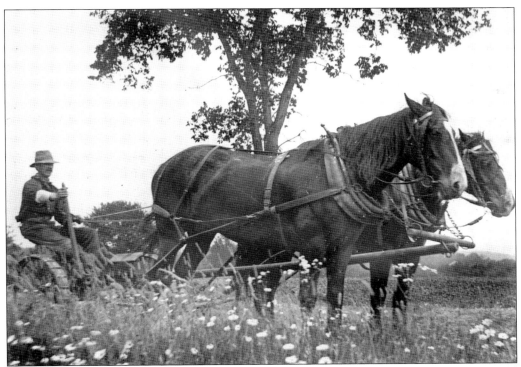

Tom Lash (1876–1926) plows the fields with his horses Bill and Nellie in 1912. Today this field is the location of the Denville Public Works complex. (Illig-Vialard Collection, DHS.)

DENVILLE'S RURAL HERITAGE

The early settlers of Denville came to the area for two main reasons: to forge iron or to till soil. Much has been written about the Morris County iron industry, which began with a forge on the Whippany River c. 1710. Denville was a large part of the iron heritage of the county, with no fewer than four forges dating from the 18th century. However, little has been told of Denville's rural heritage and of the families who farmed the land. Over the past few years, Denville has taken steps to correct this historical oversight. One of its special places managed to survive two centuries amidst the development that surrounds it. A simple farm remains to tell the other half of the story about Denville's beginnings.

The Ayers-Knuth Farm in the Franklin section of Denville was designated a state and national historic site in 1998. The farm achieved this honored status not for its greatness but for its simplicity. It remains substantially intact from its prominent time in the 1850s to its decline in the 1930s. It is a time capsule of a bygone era in a part of the country where farms were once abundant but are not easily found anymore.

The farm began on May 10, 1803, when David Garrigus sold the original 105-acre parcel, then part of Hanover Township, to his son-in-law Daniel Ayers. The deed gives no indication that there were any structures on the property at the time of the purchase. Just a few months later, Daniel Ayers's name appeared for the first time on the Hanover Township tax rolls. On the day he purchased the land, Daniel's wife, Hannah, was about three months with child. Their daughter Anna Sabrina was the first born on the new farm in November of that year.

The complex of buildings on the property tells of the growth and prosperity of the farm in the 1850s, when the farmhouse and carriage house are believed to have been built. In 1852, Daniel's son William Ayers purchased the farm and began to take over the farming operation from his father, who died in 1856. Later buildings, such as the tenant house and the icehouse-office-barn, attest to the continued expansion and prosperity under William's ownership. From the late 1860s, William's son George ran a distillery on the farm property where "Billy Ayers Apple-Jack" was made. William's younger son Lawrence was the last of the Ayers family to own the farm. He sold it to investors in 1896, ending 93 years of continuous family ownership. But records indicate that Ayers family members may have continued to live on the farm until 1900.

Martin and Anna Knuth emigrated from Germany c. 1882. Their first farm, on Zeek Road, did not have the best soil and, before long, they were looking for more fertile ground. The old Ayers Farm had gone through a succession of owners since 1896. During this time, the farm was reduced to 65 acres. However, there was still enough good farmland there to catch the attention of the Knuths. On June 4, 1906, Martin and Anna Knuth purchased the farm that would remain with their family for the next 90 years. The Knuth Farm prospered until roughly a year after Martin Knuth's death. In the summer of 1936, lightning struck a barn on the property, described by one news account as one of the largest barns in the state. The barn burned to the ground. Because an insurance policy was not renewed after Martin's death, there was no money to replace it. The farm never fully recovered from the tragedy. Siblings Frank and Susan Knuth lived modestly at the family farm until their deaths within a few months of one another in 1990.

With wide community support and a significant grant from the Morris County Open Space Trust Fund, Denville Township raised enough money to purchase 55 acres of the 65-acre farm in 1996. Since that time, a slow but steady effort has been made through volunteers to restore the complex of buildings that still remain on the property.

The story of the Ayers-Knuth Farm could be the story of any number of Denville farms, most of which no longer exist. Whether in the fertile Rockaway Valley or on the gentle rolling

fields of Union Hill, farming families like the Hill, Smith, Cobb, Poulus, Cooper, Cook, Bush, and Suk families are reminders of Denville's long tradition as a farming community. The Ayers-Knuth Farm is one of the last remaining examples of that tradition and will forever be a symbol for and a testament to Denville's proud and significant rural heritage.

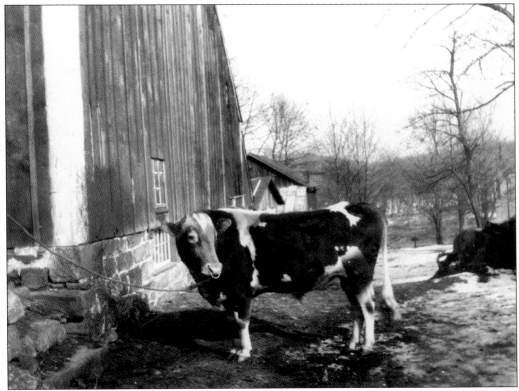

The bull on the Cobb Farm does not seem to mind having his picture taken in this c. 1899 image. The cameraman was undoubtedly relieved to know the bull was tied up. (Cobb Collection, DHS.)

The Ayers-Knuth Farm is Denville's only national historic site. Established in 1803, it is historically significant because it has been continuously farmed for nearly 200 years and has survived nearly intact. It remains a testament to the rural heritage of Denville, an area that has experienced much development. Its name is derived from the two families that owned and operated the farm for most of its 200 years: the Ayers family (1803–1896) and the Knuth family (1906–1996). The Township of Denville acquired 55 acres of the farm in 1996. The main farmhouse, in the center, dates from c. 1855. The barn, the large building on the right, dates from c. 1885. The carriage house on the left was built c. 1850. (DHS.)

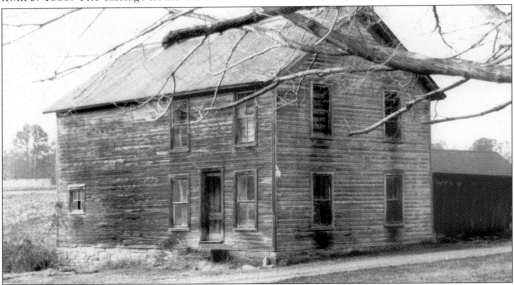

A local newspaper once described the barn that originally stood at this location on the Ayers-Knuth Farm as one of the largest barns in the state. The barn burned to the ground in the summer of 1936. Without money to rebuild the massive barn, the Knuth family made do with what they had. Initially serving as an icehouse and office, the building shown here was moved from the east side of the main farmhouse to its current location and was used as a replacement barn. This building served as a backdrop farmhouse in the movie *Torch Song Trilogy*. (DHS.)

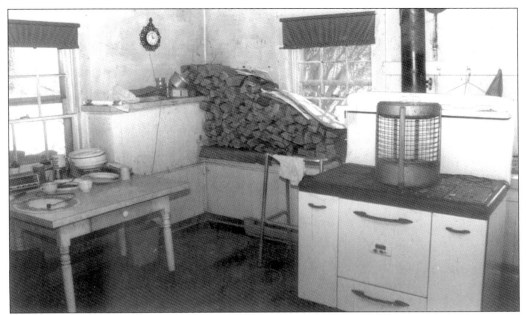

The interior of the farmhouse has remained in relatively pristine condition with no significant changes made. Electricity was not brought into the house until the 1960s. Even then only the lower floors received lighting and power. Indoor plumbing was never installed. (DHS.)

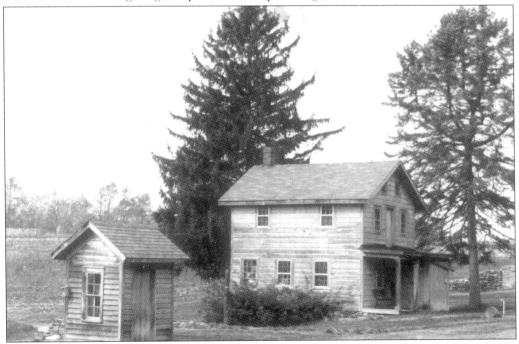

The tenant house on the Ayers-Knuth Farm dates from c. 1875. This building was specifically constructed to house farmhands and transient farm laborers. It was intentionally placed close to the main farmhouse, where the farmer could keep an eye on them. The outhouse in the foreground was still in use when the last of the resident Knuths died in 1990. (DHS.)

It may be difficult to recognize Cooper Road in this 1909 view looking west from Hill Road toward Dover. The railings of the bridge over the Den Brook can be seen along the roadway, and the old split-rail fencing used by area farmers is in the foreground. This was once the downtown area of Franklin. The riverbank to the right of the men walking down the road is the one-time location of the Franklin Forge. (DHS.)

The old headstones of the Hill Family Cemetery overlook the historic Ayers-Knuth Farm. The Carter family established a farm in Franklin sometime in the 18th century. In 1793, they sold it to David Garrigus, who was the owner and operator of the Franklin Forge nearby. Garrigus sold all his land holdings and moved to Ohio in 1806. His farm was purchased by the Hill family c. 1809. The Hill Family Cemetery dates from at least the death of Alice Hill on May 18, 1836. It is all that remains of the one-time sprawling Hill Farm. (Courtesy of Bob Illig, DHS.)

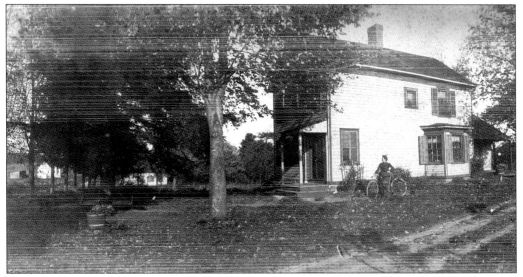

The Mahlon Smith Farm on Openaki Road is shown c. 1899. The Union Hill Presbyterian Church, built in 1897, can be seen in the distance to the left. Hardly noticeable through the trees between the church and the farmhouse is the second Union School, built in 1861. (Illig-Vialard Collection, DHS.)

The Mahlon Smith barn is shown c. 1899. Due to fire, age, or development, few of Denville's old barns still survive. (Illig-Vialard Collection, DHS.)

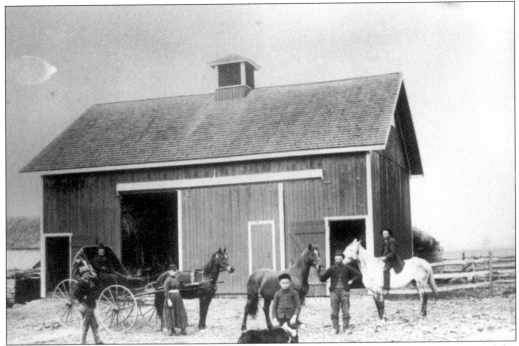

The barn from the old Baldwin homestead on Norris Road, shown here in 1888, is one of the Denville barns that did not survive. It burned to the ground. (Courtesy of J. Elizabeth Willis; Illig-Vialard Collection, DHS.)

The barn above the Cedar Gate Farm on Parks Road dates from 1903 and is now painted a vibrant red. Although the land has been substantially developed, about six acres remain as a working farm. Horses like the one in this early photograph are still kept there today. (DHS.)

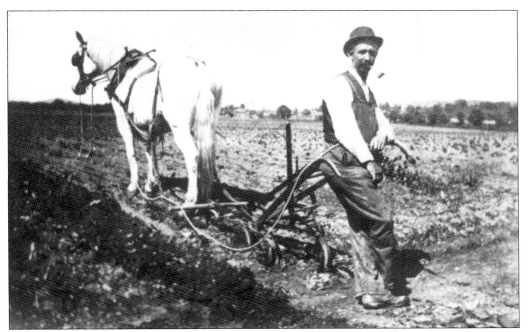

Down in the Rockaway Valley, farmer Charles Bush takes a rest from cultivating and poses for a picture. (Courtesy of J. Elizabeth Willis; Illig-Vialard Collection, DHS.)

Even downtown, Denville had its farmers. This cornfield is where the Denville Post Office is today on Church Street. The field belonged to the Shepp family and is shown c. 1947. The house seen on the left belonged to Mrs. Mortimer Hunt. (Illig-Vialard Collection, DHS.)

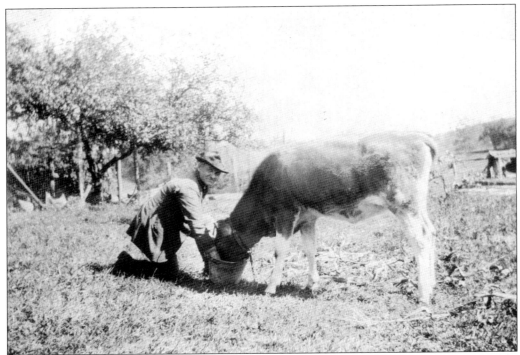

Frank Peer (1870–1932) feeds his cow on October 13, 1924. (Illig-Vialard Collection, DHS.)

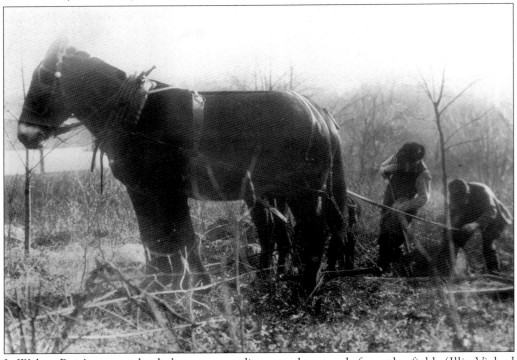

J. Walter Peer's two mules help two men dig out a large rock from the field. (Illig-Vialard Collection, DHS.)

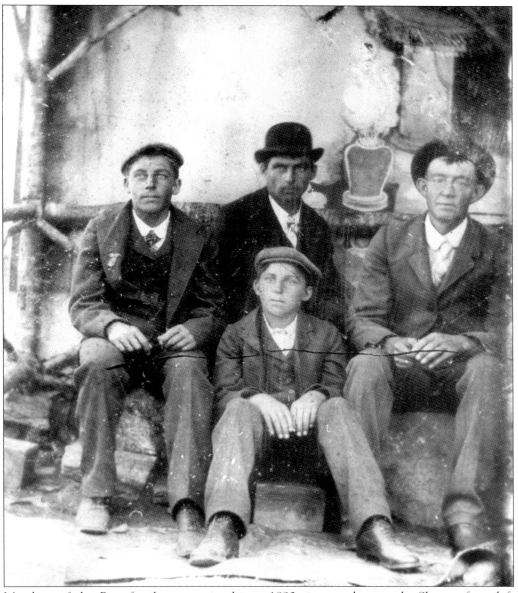

Members of the Peer family appear in this *c.* 1890 tintype photograph. Shown, from left to right, are Daniel, Munson (in bowler hat), Albert, and Samuel Peer. (Illig-Vialard Collection, DHS.)

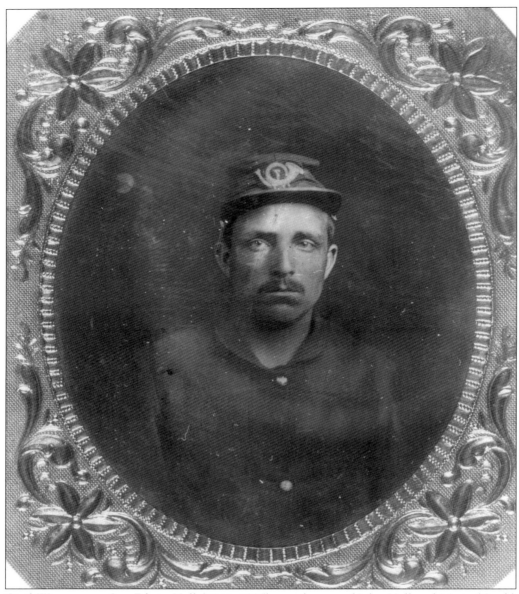

Civil War veteran Sgt. Edwin Hall (1844–1925) was the son of John Hall and Maria (Cook) Hall. He served first as a private in Company H and later in Companies K and C, 7th Regiment, New Jersey Volunteers Infantry, achieving the rank of sergeant. He was captured near Petersburg, Virginia, on June 22, 1864, and was held captive in several Confederate prisons, including Andersonville. (Courtesy of Ruth Smith; Illig-Vialard Collection, DHS.)

Six

PEOPLE AND THEIR PLACES

The S.S. Palmer house at the corner of Franklin Avenue and Franklin Road was photographed in 1900. (DHS.)

Anna Sabrina (Ayers) Cooper (1803–1892) was the eldest child of Daniel Ayers and Hannah (Garrigus) Ayers. Daniel and Hannah established the Ayers Farm on Cooper Road on land purchased from Hannah's father on May 10, 1803. A simple log structure on Anna's parent's new farm was likely her place of birth and first home. Anna married the boy from across the road. David Cooper (below) brought his bride to live at his family home, now the Hardin house at Cooper Road and Birch Run Avenue. There, Anna spent the rest of her days looking out on the farm where she was born. (Illig-Vialard Collection, DHS.)

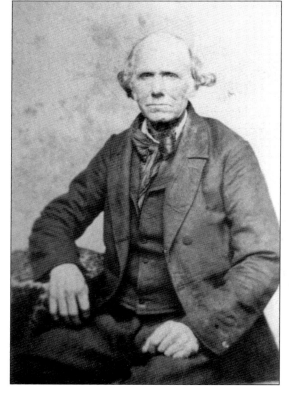

David Cooper (1801–1899) was the husband of Anna Sabrina Ayers. "Uncle David," as he was known in later years, was among Denville's first historians. His knowledge of the old families in the area and the interconnections between those families was a valuable resource to those who began to write Denville's story down. This photograph dates from the 1860s. Both David and Anna Cooper are buried in the Denville Cemetery. (Illig-Vialard Collection, DHS.)

Sarah Ann (Cooper) Fichter (1829–1920) is shown here with her husband, John S. Fichter. She was the fourth child of David and Anna (Ayers) Cooper and the granddaughter of Daniel and Hannah (Garrigus) Ayers. Like her father, she played an important role in preserving Denville's history. An interview she gave in 1919 documented her memories of Denville farm life as a girl in the 1830s and 1840s. Every history written about Denville, including this one, has contained some excerpt from that interview. (Illig-Vialard Collection, DHS.)

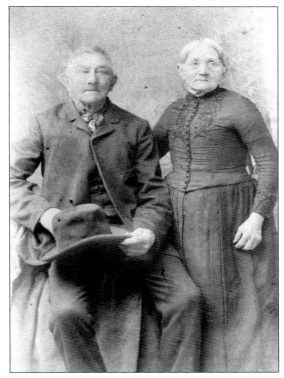

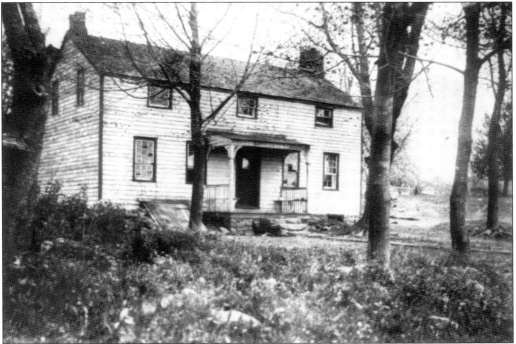

The Cooper homestead—the home of Anna Sabrina (Ayers) and David Cooper and the birthplace of Sarah Ann (Cooper) Fichter—is shown in the 1890s.

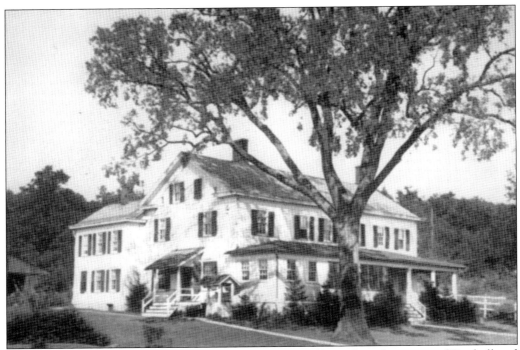

The Abraham Kitchell homestead was built *c.* 1770. It still stands at the corner of Kitchell and Ford Roads. (Illig-Vialard Collection, DHS.)

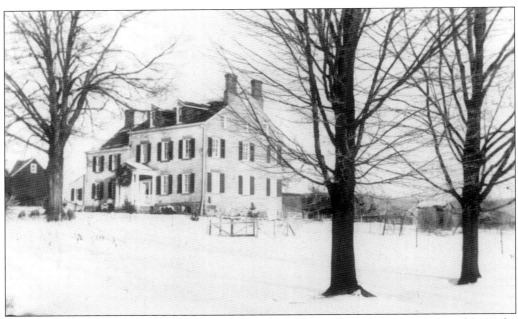

Another Kitchell homestead was known as Shadyside. It was built between 1825 and 1830 for either James or Matthias Day Kitchell. The house was destroyed when Interstate 80 was built through Denville. (Illig-Vialard Collection, DHS.)

Joseph Percy (Crane) Crayon (1841–1908)—teacher, photographer, Civil War veteran, and Denville's foremost historian—published *Rockaway Records of Morris County Families* in 1902, a phenomenal work that chronicled the genealogies and histories of Denville's pioneer families back to the earliest times. His work was based in part on interviews he had conducted with David Cooper and is remarkably detailed and accurate. He authored numerous articles on various historical subjects pertaining to Denville. During the Civil War, Crayon served for one year as a private in the 4th Battery D, Light Artillery, 1st Regiment, New Jersey Volunteers. His original surname was Crane. Reportedly, he adopted the name Crayon when he was a schoolteacher, believing that the children better remembered his name as "Mr. Crayon." Crayon is shown here in April 1868. He is buried in the Hill Cemetery. (Courtesy of J. Elizabeth Willis; Illig-Vialard Collection, DHS.)

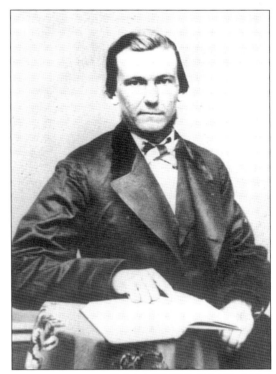

This was originally the home Gen. William Winds, who is known for arresting New Jersey's last royal governor, William Franklin, at his mansion in Perth Amboy, after the public reading of the Declaration of Independence. The house probably dates from the 1750s. It passed to the Palmer family, who ran the Franklin Forge, then to local historian Joseph P. Crayon, and finally to the Cobb family, who still owns it today. The house stands at the corner of Franklin and Cooper Roads. (Cobb Collection, DHS.)

John Gerdes (born *c.* 1877) was a bartender at the Denville Hotel. He is shown here in 1897. (DHS.)

Nicholas Lash (born 1839), Civil War veteran, was the son of Joseph P. Lash and Cynthia (Harriman) Lash. He served in Company L, 27th Regiment Infantry, for nine months during the war. He was discharged at the U.S. Army Hospital in Newark in 1863 on disability. Lash moved out west and nothing else is known of him. (Courtesy of Marshall Lash; Illig-Vialard Collection, DHS.)

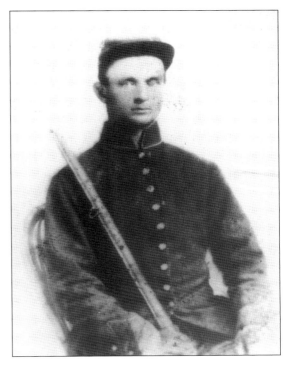

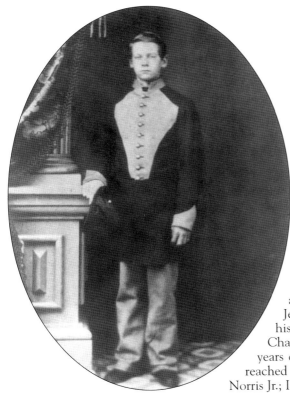

Charles Augustus Norris (1845–1928), Civil War veteran, enlisted on October 10, 1861, at just under 15 years of age. He served as a third-class musician in the band of the 4th New Jersey Volunteers Infantry. Discharged at Harrison's Landing upon the completion of his tour in August 1862, the 17-year-old Norris enlisted again a year later at Newark, New Jersey. This time he served as a private in Company C, 33rd New Jersey Volunteers Infantry. He completed his service on August 1, 1865, in Kentucky. Charles Norris completed two tours and four years of service during the Civil War before he reached his 20th birthday. (Courtesy of Charles A. Norris Jr.; Illig-Vialard Collection, DHS.)

The Wright family owned this home, still standing on Franklin Road just past the railroad underpass, on the left side headed south. The Wright Organ Factory once operated to the right of the tracks (not shown). Before the underpass was built, there was a grade crossing with a tollgate. This image dates from c. 1893. (Illig-Vialard Collection, DHS.)

Martha Ann Husk Mattoon was the first woman to work for the Delaware, Lackawanna, & Western Railroad. She was a gate tender at Fox Hill. (Illig-Vialard Collection, DHS.)

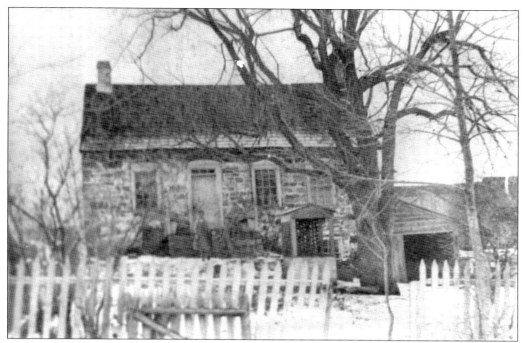

The Dickerson House, on Diamond Spring Road, is shown in 1881. It was later known as the Doremus-Henn House, so named for later owners. (Illig-Vialard Collection, DHS.)

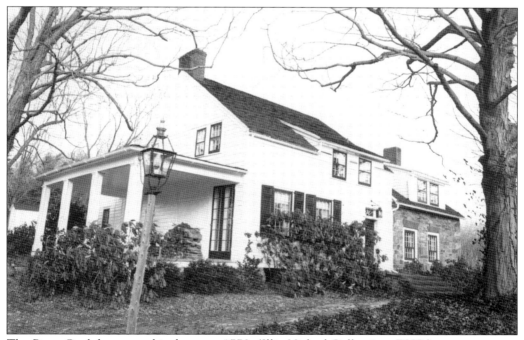

The Peter Cook homestead is shown *c.* 1778. (Illig-Vialard Collection, DHS.)

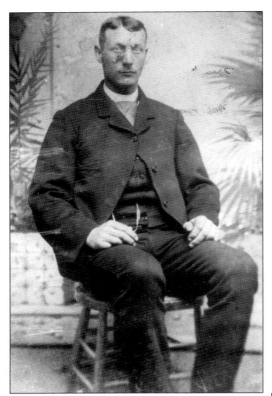

Frederick Eugene Parks (1859–1938) built Parks Road so he could take his produce to the Mount Tabor railroad station. He worked hard to obtain Denville's independence from Rockaway and became the first mayor of Denville Township from 1913 to 1924. When Denville separated from Rockaway Township in 1913, the voters elected a township committee to conduct the affairs of the town. Each year, the committee chose a chairman from among its members. Fred Parks was elected chairman 11 times. After the law was revised in the 1950s, the chairman also assumed the title of mayor. (Illig-Vialard Collection, DHS.)

Calvin L. Lawrence (1875–1949) was Denville's second mayor from 1925 to 1934. Initially serving as a member of the board of education, Lawrence became a member of the Denville Township Committee in 1915. There he served until 1934. He was elected nine times as chairman-mayor. From 1936 to 1944, Calvin Lawrence served on the Morris County Board of Chosen Freeholders. The Calvin L. Lawrence Memorial Bridge over the Rockaway River on Diamond Spring Road honors his memory and service. (Illig-Vialard Collection, DHS.)

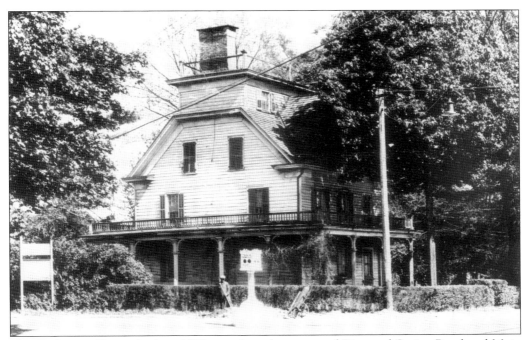

The Dickerson House, built *c.* 1800, stood on the corner of Diamond Spring Road and Main Street on the site now occupied by the Grand Union parking lot. This photograph was taken prior to 1928. (Illig-Vialard Collection, DHS.)

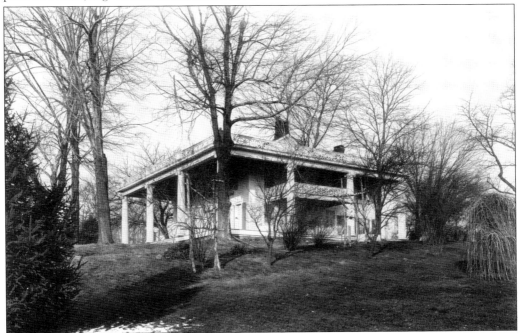

This house was known as Beau Site, the 15-acre estate of John D. Ehrgott on Pocono Road where St. Clare's Hospital is now. It was destroyed by arson on April 17, 1928. (Photograph by Edwin Levick; Illig-Vialard Collection, DHS.)

William Gerard (1873–1953) established Gerard's Drug Store on Broadway in Denville in May 1930. Gerard originally had a pharmacy in Rockaway. He and his partner, Fred Matthews, decided that Denville needed a pharmacy of its own. Together they opened Denville's first drugstore with a very fine soda fountain, famous throughout the area for its quality ice cream. Gerard's Drug Store was the only location in Denville where a customer could pay his telephone, electric, and gas bills. The store was enlarged by 50 percent with an addition to the rear in 1950. In 1952, the famous soda fountain was removed because of increasing ice-cream costs. The drugstore is still in operation at the same location. (Illig-Vialard Collection, DHS.)

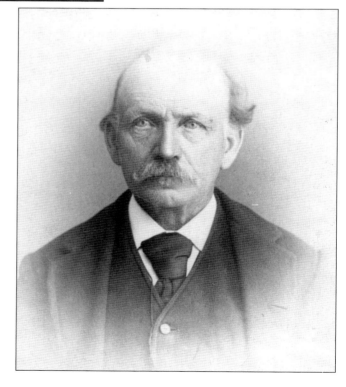

Edward C. Peer (1838–1915) ran the E.C. Peer Canal Store on Diamond Spring Road for more than 40 years. The store opened c. 1840 and continued until c. 1963. It is now the site of Attilio's Restaurant. (Illig-Vialard Collection, DHS.)

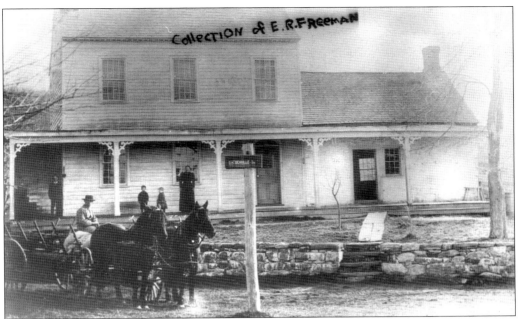

The Freeman homestead, located on the corner of Morris Avenue and Savage Road, is shown c. 1893. This was later the home of Marshall Lash. (Photograph by Fred Dickerson; Freeman Collection, DHS.)

This is the parlor of Edward C. Peer's home prior to 1919. It was located on the main floor of the store he operated along the Morris Canal. (Illig-Vialard Collection, DHS.)

Emma V. Baldwin (1877–1952) was one of America's notable pioneer librarians and a founder of the Denville Library. She was also a local historian. After the Parent-Teacher Association gave up control of the small library that its members had founded in the four-room school and later the Main Street School in 1928, it was Emma Baldwin who led the way for the formation and incorporation of the Denville Library Association. She began writing a book on Denville's history but died before it was completed. Her notes, however, gave us a picture of Denville just before the separation from Rockaway. Her research and recollections have been used in subsequent histories of Denville, including this one. The photograph dates from c. 1940. (Illig-Vialard Collection, DHS.)

Frank Pardee Baldwin (1873–1946), Spanish-American War and World War I veteran, entered the U.S. Naval Academy in 1891 and was commissioned as a regular ensign in 1897. He served continuously as a naval officer until 1915. At the entry of the United States into World War I in 1917, Baldwin was recalled to duty and served until 1919. His service included the Spanish-American War, the Philippine Insurrection, and World War I; he received medals and citations for each. He is buried at the Denville Cemetery. (Illig-Vialard Collection, DHS.)

"Uncle" Jeddy Cooper relaxes on a downtown sidewalk in the 1930s. He was Denville's first truant officer. (Illig-Vialard Collection, DHS.)

Denville teacher Mrs. Albertson sent this photograph of herself to a most deserving pupil. "To Charles E. Cisco, Denville, N.J.," she wrote, "for being the best boy in school. June 16th, 1892 A.D." (DHS.)

Seven

LESSONS LEARNED

The one-room school on Diamond Spring Road (Denville School No. 11), shown here, stood next to the Methodist Community Church. When a new two-room school was built on Main Street in 1894, the old school was abandoned and later sold to the church. The old school was moved to another location on the church's property, an event captured in the above photograph. It was leased for 14 years as a meeting place for the Denville Township Committee starting in 1913. After women's suffrage in 1920, Denville School No. 11 served as the polling place where Sarah Dickerson and Gussie Vesper became the first two Denville women to vote. Eventually the school was torn down. All that remains is the school bell, now on display at the Denville Museum. (Courtesy of Walter Joy; Illig-Vialard Collection, DHS.)

"Sometimes We Didn't Hear the Bell"

The emergence of schools in Denville generally followed the pattern of the town's development. As the population grew, the need for schools grew with it. The early Denville settlers likely made some provisions for education. Early schools allegedly existed off Ford Road, on Old Boonton Road near the Morris Canal, and in the Hinchman House (corner of Main Street and Diamond Spring Road). Little information can be found on any of these early institutions. The first schools were undoubtedly small, sometimes just a room above a tavern or a one-room structure. All eight lower grades and occasionally even high school were conducted at one time in one room with one teacher.

In Denville center, a school is believed to have existed c. 1774 near the southeast corner Bloomfield Avenue and Main Street, though no details of it have been found. The Denville School Association was chartered on June 11, 1830, following state legislation from the year before establishing the first system of public education. Local historian Charles M. toeLear concluded that the first Diamond Spring Road School was likely built around that time. The school was known to exist in 1841, from the minutes of the Methodist church that was moved "next to" the school the following year. A new Diamond Spring Road School (Denville School No. 11) was built at the same location next to the Methodist church in 1855. It continued in use as a school for about 40 years and was then sold to the church and used for a variety of things, including Denville's first municipal building.

A school is believed to have existed near the corner of Morris Avenue and Ford Road. Oral histories attest to a school at this site, but no other documentation has been found. It was reportedly in operation in the 1850s, according to two members of the Blanchard family who claim to have attended it. There is some thought that this school may have been one of the earliest in Denville.

In southern Denville, two of the three known Union Schools still exist, though they are no longer used for classes. An upper floor of a tavern that stood on Openaki Road near the lake of the same name served as a school for the area shortly after the Revolutionary War. Some have called this the first Union School, but it clearly was not. Early settlers to the area perverted the Lenape word *openaki* to *ninkey*. Accordingly, the area around Lake Openaki became known as Ninkey and developed into a distinct community centered around the forge that operated there along the Den Brook. The tavern school was more properly known as the Ninkey School.

In nearby Franklin, a school was said to have existed in 1810 near the intersection of Palmer Road and Franklin Avenue. Franklin was another distinct community in southern Denville with its own forge on the Den Brook. This school was likely known as the Franklin School.

In 1816, leaders of both the Franklin and Ninkey communities decided to establish one school for the education of the children from both areas. It was located at the halfway point between the two communities near the corner of Openaki Road and Mount Pleasant Turnpike. The deed to the site for the new school refers to the "Franklin-Ninkey Union School." This was in fact the first Union School. The union of the two communities into one school district had a lasting effect on the area. The whole southern region of Denville eventually became known as Union Hill. Old communities like Ninkey and Franklin gradually faded from maps and memories.

Arson claimed the first Union School in 1860. The people in the community responded quickly and, by 1861, the second Union School was up and running. It was built just in front of the ruins of the first school. "We used slates in those days [but] about 1897, the teacher told us to take our slates home and leave them. Modern times had come! We were to have paper and pencils," a former second Union School student told historian Joseph Percy Crayon. "Seats and desks were 'doubles'—that is two sat together. Often a younger child was seated along with an

older one so the he could be helped with his work," the man recalled. "After lunch we would go down the hill to play in the [Den Brook]. . . . Sometimes we didn't hear the bell . . . for the afternoon session," he remembered. By the beginning of the 20th century, the continued growth in the area prompted the building of the third Union School. The new school opened in 1908 and is located directly across Openaki Road from the 1861 school.

Back on Main Street, a two-room school was built c. 1894 as Denville center outgrew the old Diamond Spring Road School. It was located where the parking lot of the Schoolhouse Plaza is now. In c. 1914, this school was expanded to a four-room school by the addition of a second floor. By 1924, Denville had outgrown that school as well. A newer Main Street School was built right next to the four-room school and was doubled in size by 1929. This school and the third Union School served Denville's educational needs until 1951.

When Riverview School was completed in 1951, Main Street School was converted to a junior high school. Further growth in the southern end of town prompted the construction of Lakeview School in 1958. Finally in 1964, Valley View School was completed and the Main Street School was converted to house kindergarten through fifth grade. By 1982, school enrollment had dropped significantly and the Main Street facility was closed. It was later sold and is now occupied by apartments and businesses; it is called Schoolhouse Plaza.

Denville High School students first attended Rockaway High School, then Morris Hills High School starting in 1953, and finally Morris Knolls High School, off Franklin Avenue, since 1964. The Morris County School of Technology on Route 53 began offering classes initially as the Morris County Vocational Technical School in 1971.

Ground was broken for St. Mary's School on September 6, 1953, and classes began the following year. Morris Catholic High School opened its doors on Morris Avenue in 1958.

Students of the two-room Main Street School pose in this early-1900s photograph. (Illig-Vialard Collection, DHS.)

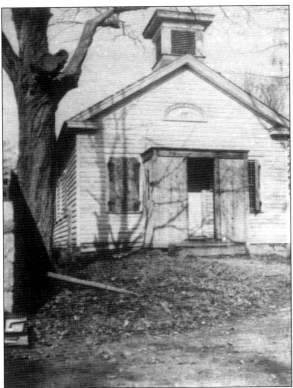

The sign above the door of the one-room school on Diamond Spring Road reads, "Denville School No. 11, 1855." There is some confusion as to the date the school was built and whether it replaced another school building at the same location. Minutes from the Methodist church of April 1841 specify that the church was to be moved next to the school. One historian concluded that the school dates from c. 1830, when the Denville School Association was incorporated. More likely, the schoolhouse shown here was a newer school, built in 1855 as the sign states, at or near the site of an earlier school that may have dated from 1830. (Courtesy of Minnie Shepps; Illig-Vialard Collection, DHS.)

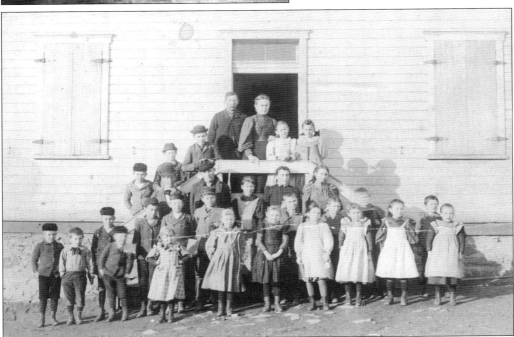

This very old school photograph was taken in front of Denville School No. 11, perhaps in 1880 or before. (DHS.)

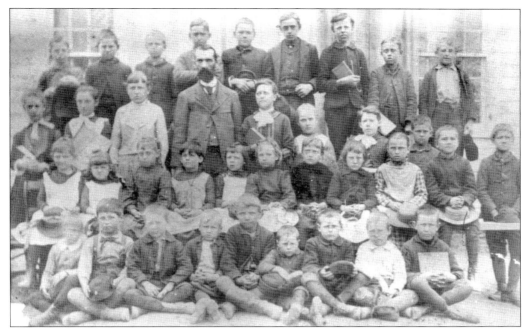

Students pose in front of Denville School No. 11 with their teacher, Mr. Johnson, in 1889. Local historian Charles M. toeLear wrote: "When the youngsters wanted a day off, one of them might put a piece of damp leather or some other material that would burn with [a] bad . . . odor, into the charcoal pot. . . . The schoolmaster would have to dismiss school." (Courtesy of Raymond Righter; Illig-Vialard Collection, DHS.)

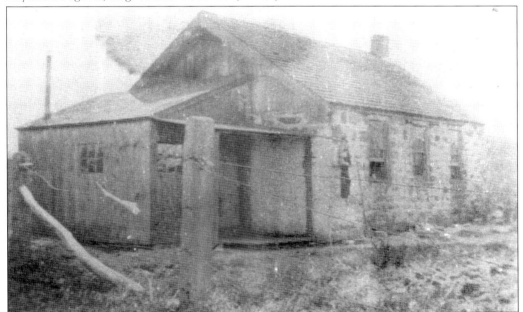

This photograph is believed to be of the older one-room schoolhouse that stood near Morris Avenue and Ford Road. Denville residents Edward Blanchard (born 1852) and J. Harvey Blanchard (born 1859) are said to have attended this school. (Illig-Vialard Collection, DHS.)

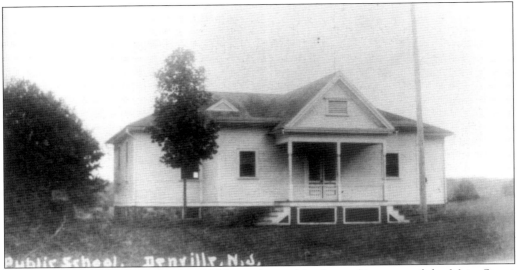

A two-room school, shown here in 1906, was located in the parking area of the Main Street School building, now used for business and residential purposes. It was built c. 1894 and was expanded to four-rooms in 1914. (Illig-Vialard Collection, DHS.)

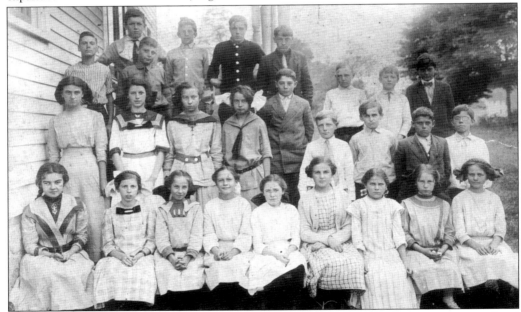

Agusta Adams, Mrs. Charles Peer, and Mr. Griswold were teachers at the two-room school in the early 1900s. Some of their students are shown in this class photograph. Posing, from left to right, are the following: (first row) Laura Vanderhoff, Edith Moore, unidentified, Gladys Jones, unidentified, Bessie Vanderhoff, Helen Beatty, Minnie Dickerson, and Hazel Vanderhoff; (second row) Harold Sofield, Samuel Van Orden, Peter Peer, and Leslie Freeman; (third row) Della Sturtevant, Augusta Moore, unidentified, Gladys Van Orden, Frank Caruso, Charlie Jagger, Harold Jagger, and Luther Van Orden; (fourth row) Warren Van Orden, Raymond Spear, Raymond Bush, Merrill Morgan, Lester Beam, and Byard Peer. (Illig-Vialard Collection, DHS.)

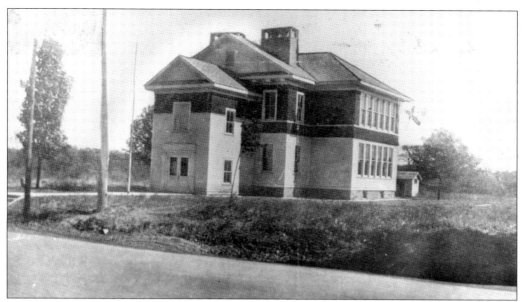

The two-room Main Street School was expanded in 1914 by adding an upper floor with two additional classrooms to accommodate Denville's growing population. The new four-room school, shown after the expansion, was replaced by the Main Street School in 1924. (DHS.)

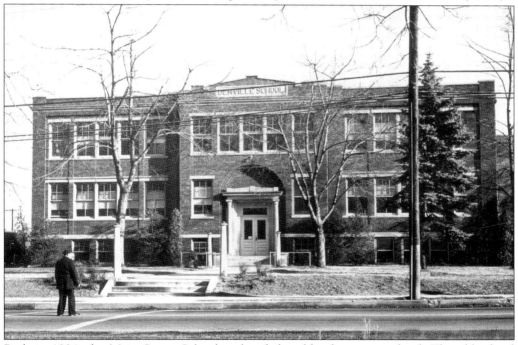

Built in 1924, the Main Street School replaced the older four-room school. The old school remained for a while right next to the new school but was eventually demolished and its parts used to construct other buildings. The new Main Street School was doubled in size in 1929. Officer Jack Kelly is seen directing traffic in front of the Main Street School. (Courtesy of Jesse Wilson; Illig-Vialard Collection, DHS.)

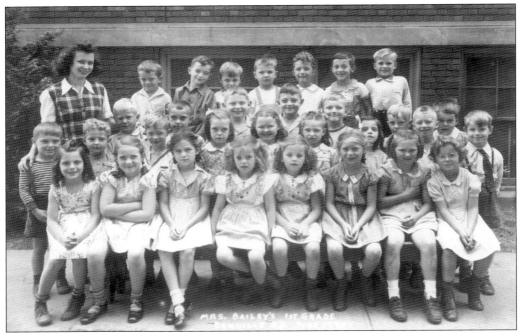

The annual class photograph always captured more fond memories than memorable facial expressions. Here, Mrs. Bailey's first-grade class poses at the Main Street School in June 1944. (Courtesy of Jesse Wilson; Illig-Vialard Collection, DHS.)

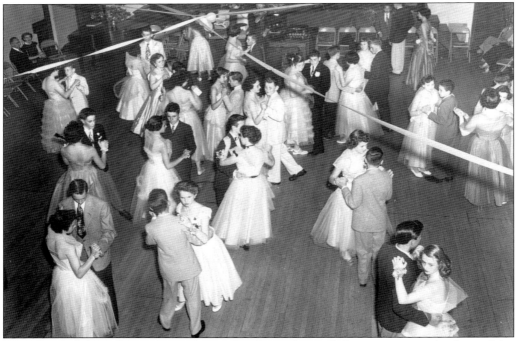

Denville's eighth-grade prom, complete with a disc jockey and chaperones, was a big hit on May 7, 1954. (Courtesy of Jesse Wilson; Illig-Vialard Collection, DHS.)

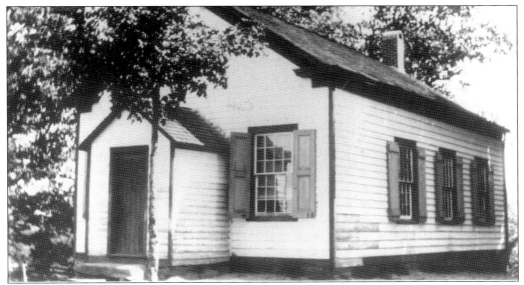

The first Union School, built in 1816, was destroyed by arson in 1860. The second Union School, shown here, was completed in 1861. It is located just in front of where the old schoolhouse use to be and is now a residence. It is not clear whether the second Union School was no longer used when the third school opened across the street in 1908. There may have been a time when both the second and third schools were used simultaneously. What is clear is that there was a school in operation at roughly the same location in Union Hill for 142 years (1816–1958). (Cobb Collection, DHS.)

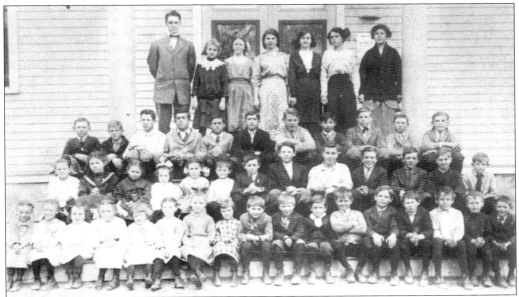

The third Union School opened in 1908 and now serves as the Denville Board of Education offices. Here, students from kindergarten through eighth grade pose in front of the school in 1915. The boy pictured in the second row from the top, fourth from the right, is young Frank Knuth. He was the last surviving member of the Knuth family to live on the now historic Ayers-Knuth Farm. (Courtesy of J. Elizabeth Willis; Illig-Vialard Collection, DHS.)

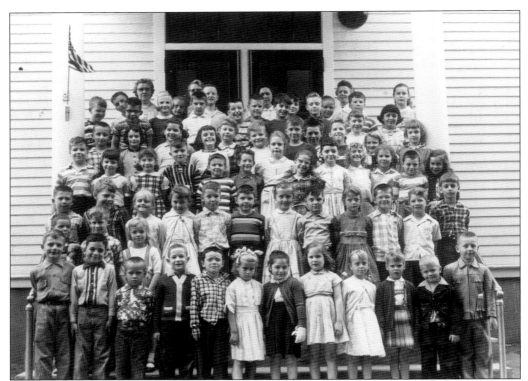

The third Union School's student body is captured here for the last time in June 1958. Lakeview School opened on Cooper Road in September 1958. Shown are the third Union School's last kindergarten through fourth-grade classes. (Photograph by Doug Faber, DHS.)

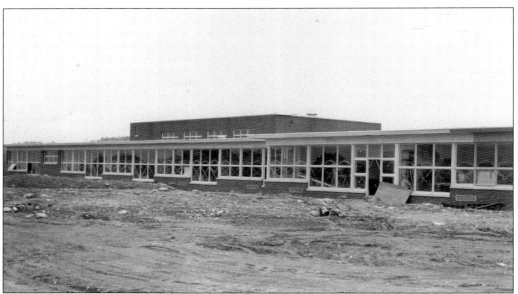

Lakeview School was under construction in 1958. (Photograph by Doug Faber; Illig-Vialard Collection, DHS.)

Eight

KEEPING FAITH

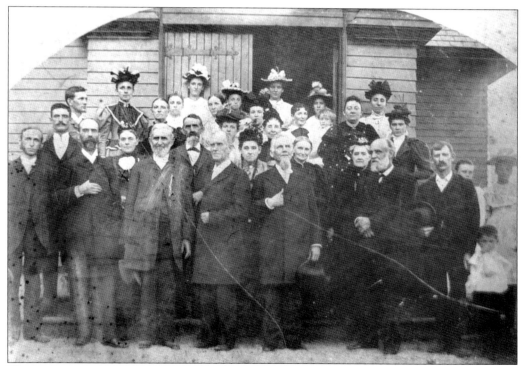

The congregation of the Denville Community Methodist Episcopal Church was photographed *c*. 1895. (Illig-Vialard Collection, DHS.)

A Place to Worship As One Chooses

Denville has always been a place of religious tolerance and freedom. The early Quaker proprietors acquired lands in the Denville area as a place of refuge for fellow Quakers who were persecuted for their beliefs in England and other places. Members of the Garrigues family were aristocrats and nobility in France in the 17th century. When their right to practice Protestantism was revoked in 1685, they were forced to flee, eventually landing in Philadelphia. There they adopted the Quaker faith. One family member migrated north to the Denville area. He became a Presbyterian and eventually joined in the American Revolution. These two decisions would make him an outcast from his Philadelphia family. He accordingly dropped the letter e from his name to distinguish himself from the rest. He was thereafter known as Jacob Garrigus.

The oldest church community in Denville is the Community Methodist Episcopal Church. Now located on Diamond Spring Road, the early church in the 18th century conducted services in members' homes with a preacher who undoubtedly traveled between communities of the same faith. The Methodist Episcopal Church in Rockaway Valley, as it was initially known, incorporated for the first time in June 1799 and again in 1810. A church was erected in 1814 along Pocono Road at Cook's Corner. A regular minister was also installed at that time. Eventually, Rockaway Valley and Denville split off from the original church and established separate churches in their own communities.

It was resolved by the trustees in 1841 that the church building should be moved to Diamond Spring Road in Denville next to the old schoolhouse. During three days in May the following year, the church building was moved piece by piece and reassembled at the new location. The Methodist Episcopal Church of Denville was dedicated with 103 members. Some 52 years later, a new church building was constructed and dedicated on July 19, 1894. The current church building was dedicated in 1962 and has been expanded twice since then.

The Union Hill Presbyterian Church evolved out of the older Rockaway Church. A Sunday school started in 1815 by Electra Beach Jackson in connection with the Rockaway Church eventually started meeting at the first Union School and later at the second Union School. The first church services were held at the first Union School beginning in 1816. After this arrangement had continued for many years, in 1879 the people decided to build a church. Land was purchased at the corner of Mount Pleasant Turnpike and Franklin Road, and the community started to raise the money for building materials. The people planned to build the structure themselves. Ground for the Union Hill Chapel was broken on December 18, 1897, and dedicated on April 18, 1899.

After the Sisters of the Sorrowful Mother acquired the old Glover Farm on Pocono Road and established St. Francis Health Resort in 1895, Catholic services began to be held in the old Glover Mansion, which was converted into a chapel. The mansion, built c. 1816, continued as a Catholic chapel until 1915.

The story of St. Mary's Roman Catholic Church begins c. 1925. Before St. Mary's, Denville Catholics attended Mass at the Chapel of St. Francis Health Resort off Pocono Road or other Catholic churches in Rockaway, Boonton, or Dover. The bishop ordered that Denville become a mission parish of St. Cecelia's Church in Rockaway. On September 29, 1925, St. Mary's was chartered as a separate parish. The church quickly purchased six lots along old Highway 6 where the groundbreaking for a new church building was held on December 8, 1925. The structure was completed the following May and dedicated in August 1926.

The Church of the Savior Episcopal Church was established as a mission in Denville on June 30, 1955; services began later that year. The church building at 155 Morris Avenue was dedicated on Palm Sunday 1959.

The Denville Bible Fellowship Church began with five families who regularly held prayer meetings in their homes. The first pastor joined the church on October 20, 1957. Construction on the church building on Diamond Spring Road began in 1962 after several years of planning. The first services at the new building were conducted on September 22, 1962.

The Lakeland First Church of the Nazarene, now on Cooper Road, was organized in 1925 in Dover. In 1977, the church relocated to Denville and the current building was constructed.

The Prince of Peace Lutheran Church on Knoll Drive began in Denville in 1960 out of a growing need for a new Lutheran church in the area. Services were first held in the Main Street School in 1964. The church building was dedicated in 1965.

Some other churches have come and gone, but Denville remains a place to worship as one chooses.

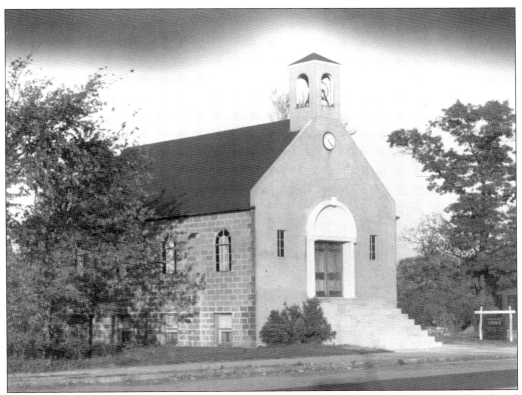

Formed in 1929, the nondenominational church building on Broadway was completed and opened for service in May 1942. By the 1960s, membership diminished significantly and the church resorted to rummage sales and other fundraisers for support. In 1975, the church had only one service for the entire year : the annual Christmas service. All services were finally terminated in 1982. The property was sold in 1987, and the revenue was disbursed to several area churches. The building was torn down in 1988. (Illig-Vialard Collection, DHS.)

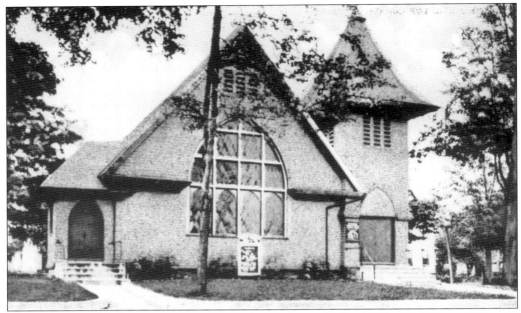

The Denville Community Church began as the Rockaway Valley Methodist Episcopal Church in the 18th century and is the oldest church community in Denville. The first church building was located on Pocono Road at a place called Cook's Corner. The building was moved piece by piece next to the old Denville School No. 11 on Diamond Spring Road and reassembled in 1842. In 1880, a fund was started for the construction of a new church building. That new building, shown here, was dedicated on July 19, 1894. (Illig-Vialard Collection, DHS.)

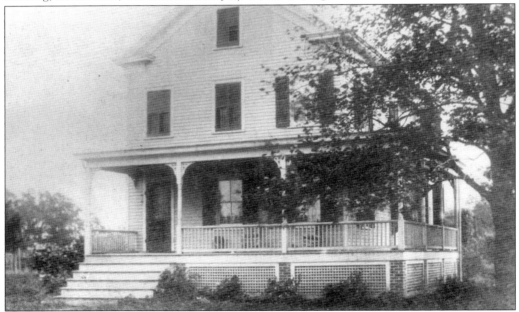

The Community Methodist Episcopal Church parsonage, shown in 1906, was built c. 1873 and was located at 77 Diamond Spring Road. This building was periodically enlarged and served as the parsonage until 1955. (Illig-Vialard Collection, DHS.)

Mother Superior Florina takes shovel in hand to break ground for St. Clare's Hospital on Labor Day 1950. She was joined by the Most Reverend Francis J. Tief, archbishop of Newark, and the Very Reverend Msgr. Andrew V. Stefan, vice chancellor of the Diocese of Paterson, representing the bishop. (DHS.)

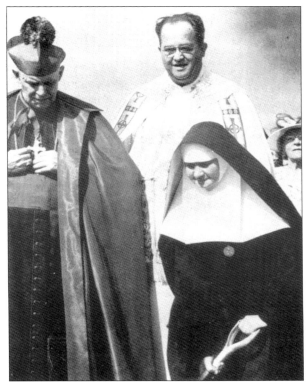

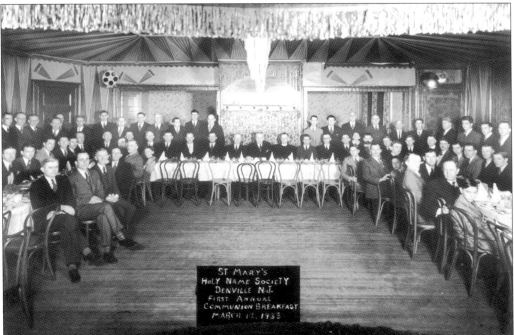

The St. Mary's Holy Name Society held its first annual Communion Breakfast on March 12, 1933. It was held at the Wayside Inn. (Courtesy of Jesse Wilson; Illig-Vialard Collection, DHS.)

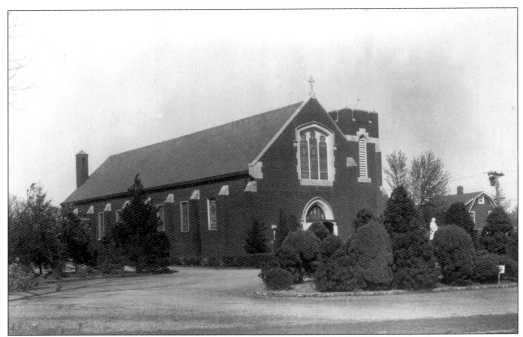

Ground was broken for St. Mary's Roman Catholic Church on December 8, 1925. The cornerstone was set the following May, and the new church was dedicated on August 15, 1926. This photograph shows the church in the 1930s. (Photograph by P. Flormann, DHS.)

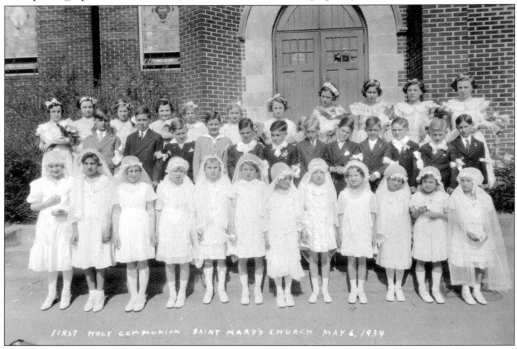

FIRST HOLY COMMUNION SAINT MARY'S CHURCH MAY 6, 1934

This photograph was taken on May 6, 1934, during first holy communion ceremonies at St. Mary's Church. (Courtesy of Jessie Wilson; Illig-Vialard Collection, DHS.)

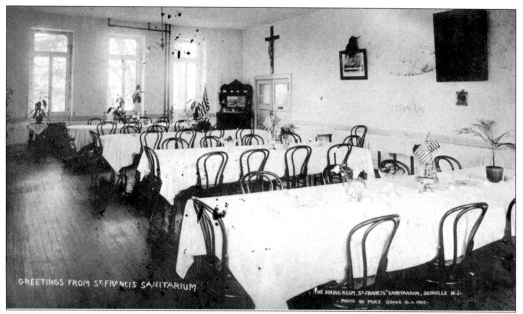

GREETINGS FROM ST. FRANCIS SANITARIUM

THE DINING ROOM, ST. FRANCIS SANITARIUM, DENVILLE N.J.
- PHOTO BY PRICE DOVER N.J. 1905-

The St. Francis Health Resort was started by the Sisters of the Sorrowful Mother in 1896, a year after they purchased the property. The resort was known throughout the world for sponsoring the famous Kneipp Water Cure for convalescents and making it available to the public at nominal cost. The first guesthouse was built in 1896, and another was built in 1902. There were a number of expansions of the main structure through 1927. This photograph shows the dining room as it appeared in 1905. (DHS.)

Long before the St. Clare's Hospital Harvest Festival was initiated in 1974, St. Francis Health Resort observed harvest time as a special season. The chapel is decorated with colors of the harvest in the early 1900s. (DHS.)

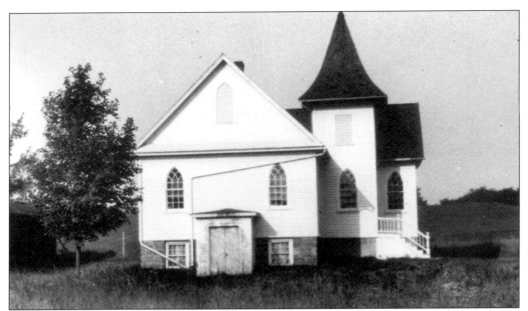

Construction began for the building of the Union Hill Chapel on December 18, 1897, and was completed by 1899. The Union Hill Presbyterian Church sprang from the community of the Rockaway Presbyterian Church started in 1758. The congregation in Union Hill raised the money themselves and together built the chapel with the money raised. (DHS.)

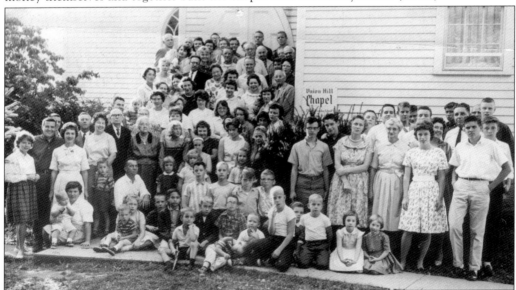

The congregation of the Union Hill Presbyterian Church is seen in the early 1960s. Their ancestors 70 years earlier had come together to build the chapel. An article in the June 23, 1893 issue of the *Rockaway Record* gives insight into how the money was raised: "On Thursday evening an ice cream and strawberry festival was held at the Union School house for the benefit of the new chapel which is to be erected . . . on a lot recently purchased from W.H. Casterline for $75. The main building will be 24 by 36 feet with an ell of 12 by 16 feet. The people of this place will do the work themselves." (DHS.)

Nine

SUNDAY AFTERNOONS

The men of the Denville Athletic Club meet at the Wayside Inn in 1927. At the front table, from front to back, are Lester Beam, Hugh Sweeney, Bert Smith, Bill Keefe, George Van Orden, Bill Shottman, Bob Ewald, Phil Teare, and Fred Jagger. At the second table in the front row, from front to back, are Harold Cook, Robert Rownan, Joe Jones, James Gallagher, Horace Cook, Fred Meyers, Frank Vanderhoof, unidentified, and Judge Bill Keefe. At the second table in the back row, from front to back, are Peter Peer, Francis Philippe, unidentified, Raymond Collins, Ogden Collins, George Vanderhoof, and Jake Powell. Standing against the back wall, from left to right, are Charles Jagger, ? Metts, Sam Van Orden, George D. Van Orden, Lou Peer, and Bill Sweeney. (Illig-Vialard Collection, DHS.)

DENVILLE AT PLAY

Denville folks have always enjoyed their leisure time, and there is always something to do to match every taste and interest. Whether organized sporting events, a bike ride, or hike through the woods, Denville offers a wide variety of annual events and recreational activities.

Tens of thousands of people from all reaches flock to the annual St. Clare's Hospital Harvest Festival on the first Saturday in October, where a variety of international foods can be sampled. Special items in the Christmas or Craft Barns and lost treasures in the antique barn can be found. Children always enjoy the many rides and games available at the festival.

The Rotary Street Festival is the highlight of June. Broadway is sealed off to traffic and the whole downtown becomes a giant pedestrian mall. Rides, balloons, clowns, and more can be found at this annual event. June is also the time when the renowned Run for the Roses 10-kilometer race is held.

The Joey Bella Beefsteak Dinner and Lip Sync Contest is the highlight of the Fourth of July weekend. About 1,500 friends and neighbors pack into a big top tent for this most worthy fundraiser benefiting sick children and their families.

Broadway closes again in August for the annual Chamber of Commerce Block Party. Antique cars line the street for inspection and admiration. There are dance and Hula-Hoop contests and prizes galore. A petting zoo is a highlight for the children, and there is a lot of singing and dancing for everyone.

The Thanksgiving weekend holiday festivities in Denville are great fun. There are several days of events planned, sure to bring out the holiday spirit in everyone. From the Mr. and Miss Denville Contest, to carolers, and the annual Holiday Parade, many Denville families make it a point to be home for the Thanksgiving holiday so they do not miss any of the excitement. On each Friday night after Thanksgiving, Broadway transforms into a wonderland where cartoon characters wander around greeting their young fans. The annual Christmas tree lighting ceremony is held on Saturday at the Rotary's Santa Land. The menorah lighting at Chanukah has become a popular annual Denville tradition. On Christmas Eve, Denville's volunteer firemen donate their time to make sure Santa drops by every neighborhood on the fire engine.

The Denville Historical Society offers changing exhibits each year pertaining to local history. The annual house tour sponsored by the society gives everyone a chance to see how some of their neighbors live. The holiday concert gets better every year and has become the Denville tradition of which the historical society is most proud.

Denville has a long tradition of honoring its veterans and the memories of those who gave their life for our country. The annual Memorial Day Parade is a solemn event followed by a ceremony at the Denville Cemetery.

The Little League Parade is April's main event each year and is where hundreds of Denville boys and girls on baseball and softball teams march down Broadway to proclaim that opening day has arrived.

Hundreds of Denville's little ghosts and goblins can be found haunting Broadway and Main Street each October in the annual Halloween Parade. The children march to the Main Street Firehouse, where prizes are awarded.

Denville's policemen of the Police Athletic League (PAL) volunteer their time to run the PAL Olympics in the years that the regular Olympic games are held. All kinds of events are held that allow young people the chance to excel. The Police Athletic League is always there to help no matter what the event.

Denville has first-rate sporting complexes at Gardner Field on Savage Road, Veterans Memorial Park on Zeek Road, and the Ayers-Knuth Farm soccer fields on Cooper Road.

Generous business owners, organizations, and individuals sponsor teams in every conceivable sport year after year. It is not often anyone will find an empty ball field anywhere in Denville.

It is just not possible to list all the great things that go on in Denville. Whether it be on a Sunday afternoon, a carefree a summer morning, or after a long day on the job, Denville has always offered something for everyone.

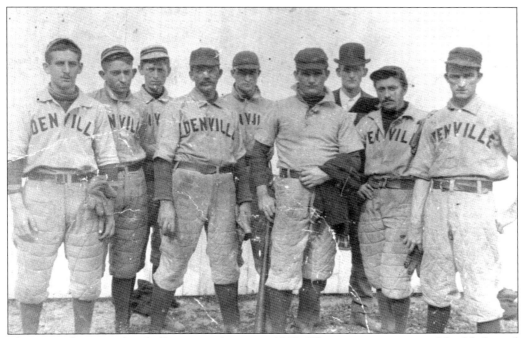

The Denville men's baseball team is shown c. 1900. The team was managed by Nathaniel "Skinny" Dickerson (second from left). From left to right are Lew Peer, Nathaniel "Skinny" Dickerson, Fred Myers, Dan Righter, two unidentified players, George Lash, unidentified, and Frank Righter. (Illig-Vialard Collection, DHS.)

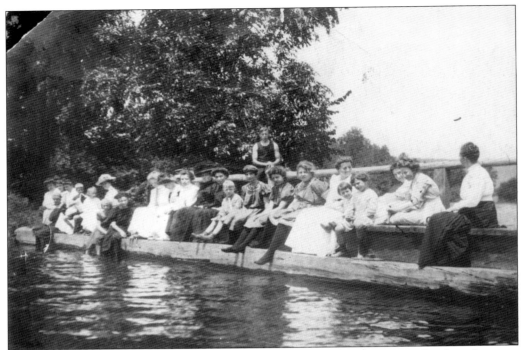

The Morris Canal aqueduct behind Peer's Lock was a popular place on a Sunday afternoon during the summertime. As canal boat traffic lessened because of newer and faster means of transporting goods, the canal became a tempting spot to cool off on a hot summer day. This photograph was taken *c.* 1915. (Illig-Vialard Collection, DHS.)

These youngsters were not about to waste one minute of their Sunday afternoon in 1915 waiting to go into the canal for a swim. From left to right are August Merz Jr., Florence Merz, Joseph Henry Bacheller Jr., John Smith Bacheller, and Muriel Bacheller. (Illig-Vialard Collection, DHS.)

Mrs. Sidney Collins and her son Harold spend their Sunday afternoon rowing in the Morris Canal basin near Savage Road in 1904. (Illig-Vialard Collection, DHS.)

The canal basin was not very deep along its banks. It made a more suitable place than the aqueduct for younger children to take a Sunday afternoon dip, c. 1910. (Illig-Vialard Collection, DHS.)

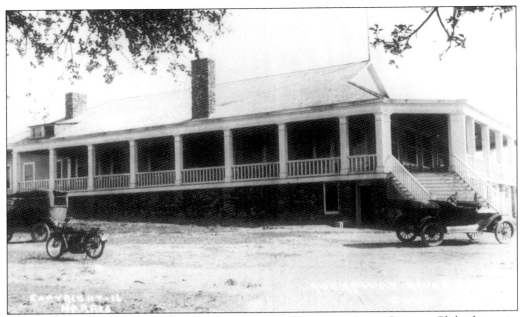

According to local historian Charles M. toeLear, the Rockaway River Country Club, shown in the 1920s, was "laid out in 1914 as a nine hole course and increased to 18 holes in 1922 as a membership owned club." (Collection of Muriel Parker, courtesy of Jesse Wilson; Illig-Vialard Collection, DHS.)

Golfers Calvin Neely (far right) and J. Henry Bacheller (fourth from left) join friends for a Sunday afternoon of golf at the Rockaway River Country Club in the late 1920s. (Collection of Muriel Parker, courtesy of Jesse Wilson; Illig-Vialard Collection, DHS.)

Imperial Field was located where the Morris County School of Technology stands today, at the corner of Route 53 and Fox Hill Road. Imperial Field's large grandstands were usually filled to capacity for the many Denville sporting events held there well before anyone ever conceived of Gardner Field. In this 1940s photograph, looking south along Route 53, Mount Tabor houses can be seen in the distance. (Courtesy of Jesse Wilson; Illig-Vialard Collection, DHS.)

Local football teams take to the gridiron at Denville's Imperial Field on a Sunday afternoon in the 1930s. The hill rising on the left side is Beacon Hill. Denville Township rented this field from the Imperial Laundry for $1 a year. The property was sold in 1946, but the field remained in use until 1952. The grandstand was removed c. 1949. (Illig-Vialard Collection, DHS.)

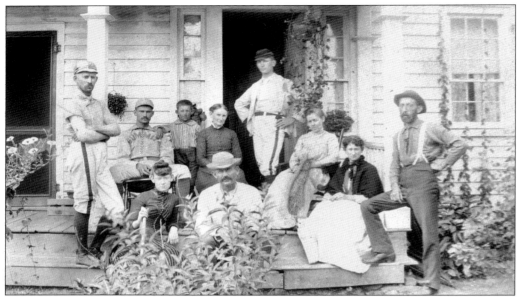

A Sunday afternoon Denville baseball outing was recorded by the camera of T.P. Crane & Company *c.* 1890, perhaps earlier. On the way to the game, the Righter family is shown at their home, which once stood on Diamond Spring Road where the Sovereign Bank is now located. The player standing in the doorway is Joseph B. Righter. His mother is seated to his left. Seated next to the small boy is Dan Righter, and standing on the far left is Frank Righter. (Photograph by T.P. Crane & Company, DHS.)

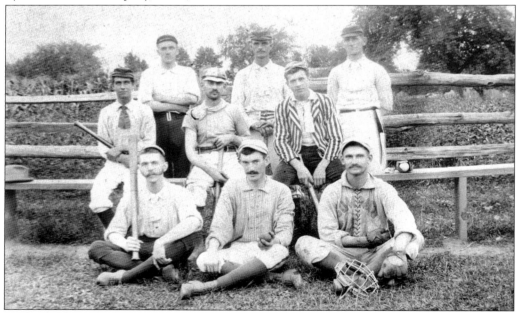

At the field on Church Street, the team poses before the cry of "Play ball!" Standing on the far right is Joseph B. Righter. In the middle row center is Frank Righter, and seated far right is Dan Righter. It is not known why Dan Righter is wearing a Summit uniform; possibly he played for a team there as well. (Courtesy of Claude E. Dickerson, DHS.)

Spectators came from all over to watch the game that day. Notice how well dressed everyone is for a baseball game in a cornfield. The fans likely headed to the field right after Sunday church services, still dressed in their Sunday best. Even the women came to enjoy the game. Here they squeeze into the limited seating along the fence of the field. (Courtesy of Raymond Righter, DHS.)

The men and boys had to sit atop the fence or just stand and watch the game. Some were lucky enough to find a clean patch of grass to sit on so as not to soil their suits. In any event, it was a most enjoyable way to spend a Sunday afternoon. (Courtesy of Raymond Righter, DHS.)

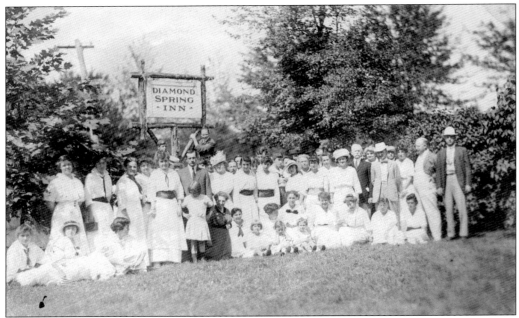

The Diamond Spring Inn developed into a first-rate resort in Denville beginning in 1909, when it began taking visitors. Some local residents got their first glimpse of Denville from a vacation they spent at the Diamond Spring Inn. This *c.* 1920 photograph shows a group enjoying one of the inn's Sunday outings. (Illig-Vialard Collection, DHS.)

They could lead this horse to water but could not teach him to skip stones with some Denville children by the old barn at the Diamond Spring in 1905. (Illig-Vialard Collection, DHS.)

In the southern end of town, residents spend a Sunday afternoon in 1915 strolling along the Cooper Road bridge over the Den Brook where William Penn's surveyors had first explored 200 years earlier. Shown are Leroy A. Davenport; his sister Ruth M. Restaino; and his wife, Johanna. (Illig-Vialard Collection, DHS.)

Eugene "Did" Peer plays with his toy car on Sunday, October 12, 1924. Peer's Store is in the background. (Illig-Vialard Collection, DHS.)

Cedar Lake was used as a fishing club from 1900 to 1906. Fishing enthusiasts still found the lake to be a special fishing spot on a Sunday afternoon in the late 1930s, when this photograph was taken. (Photograph by P. Flormann, DHS.)

Sailing on Cedar Lake in the 1920s, boaters could not miss Elizabeth Harman's store, shown here. (Illig-Vialard Collection, DHS; courtesy of Claire Patterson.)

Many Lake Arrowhead residents still enjoy quiet Sundays looking out on the lake constructed by the Arthur D. Crane Company in 1925. This view shows the lake from Mosswood Trail in 1940. (Photograph by F. Bebon, DHS.)

A playful Denville pooch relaxes along the Rockaway River c. 1900, after a cooling Sunday afternoon dip behind Peer's Store. In the distance is the Morris Canal aqueduct over the river coming from Peer's Lock. The Rockaway River Country Club golf course is now on the right riverbank. (Illig-Vialard Collection, DHS.)

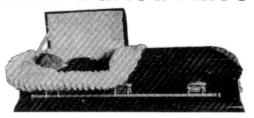

THRILLS-CHILLS

SEE
Man Buried Alive

Can Prof. Ray Richards break the World's Record of 42 days
...AT...
DENVILLE SHACK
DENVILLE, N. J. (Route No. 6)
MAY 14TH, AT 2 P. M.
SEEING IS BELIEVING. FOLLOW THE CROWD.

Prof. Ray Richards (below, center) of Pennsylvania was buried alive at the Denville Shack on May 14, 1933, seeking to break the 42-day world record. He did not make it. He was "exhumed" after 22 days on June 3, 1933. He was taken to a barbershop on Main Street, where he posed for the photograph below. From left to right are Chief Ben Kinsey, Off. Joe Maguire, Mrs. Richards, Ray Richards, Bill Samson, "Doc" Gauer, Off. Jim Lash, and the barber Jack DeLoche. Richards was having his beard shaved off after all that time underground. To the left is a promotional advertisement used to generate interest in the event. (DHS.)

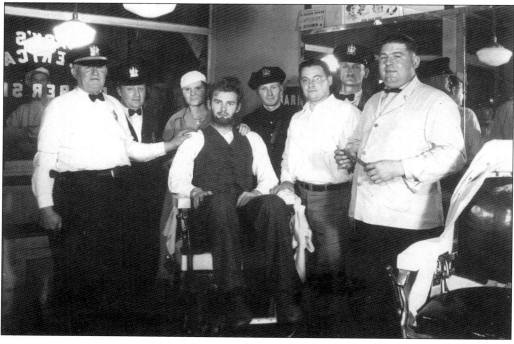

Ten

IT HAPPENED
IN DENVILLE

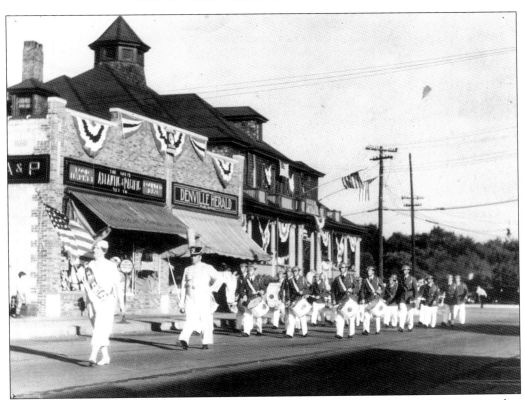

Denville held its first Memorial Day Parade in 1930, and the annual event continues today. In this 1930s view, a marching band passes the Wayside Inn along Main Street. (Illig-Vialard Collection, DHS.)

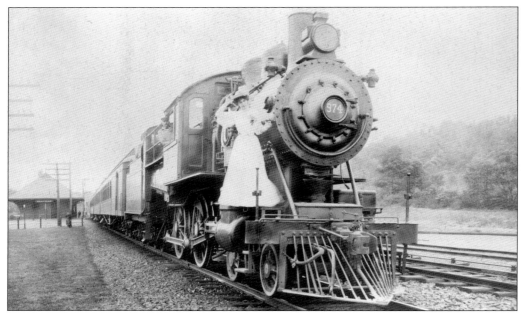

In 1905, the Denville railroad station (left) was used as a backdrop for this publicity photograph for actress Marion Murray, who was featured in the 1903 Edison film classic *The Great Train Robbery*. She is photographed here on the first "Phoebe Snow." This may have also had something to do with the film *The Train Wreckers*, another early Edison flick filmed in the Rockaway area by E.S. Porter in 1905. Some scenes appear to be filmed at the old Denville railroad tower. (Courtesy of the Railroad Museum of Pennsylvania [PHMC]; Illig-Vialard Collection, DHS.)

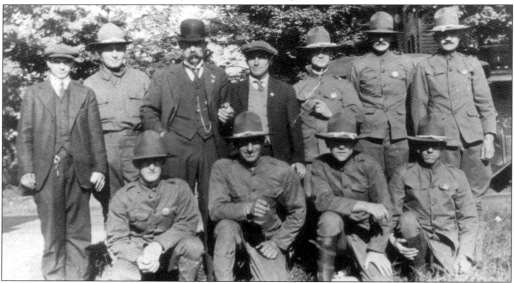

Denville's Home Guard during World War I was ready to protect the public from any wartime disaster. From left to right are the following: (front row) Wallace Peer, Howard Baxter, William Clark, and Arthur Peer; (back row) George Freeman, Stewart Peer, Hugh Sweeney, Peter Peer, Russell Metz, George Lash, and Harry Dickerson. (Courtesy of Claude Lash, Illig-Vialard Collection, DHS.)

Denville veterans use their free time on September 18, 1930, to throw a party for one of their own. The honoree is Civil War veteran James Brannin (1833–1931), shown in the center. Brannin enlisted in 1862 and served as a private in Company E, 11th Regiment, New Jersey Volunteers Infantry. He achieved the rank of corporal and was wounded in his left hand during the war. (Illig-Vialard Collection, DHS.)

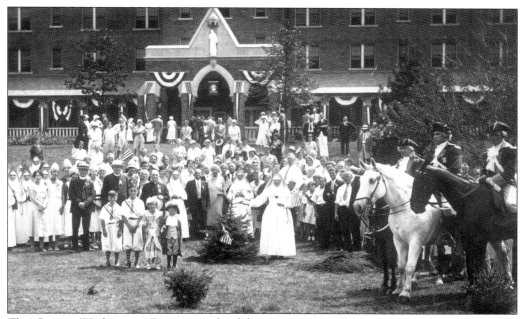

The George Washington Bicentennial celebration in Denville in 1932 was one of the first big events that attracted people from all over the area to Denville. The festivities included a pageant, a parade, a beauty contest, a baby parade and contest, a fireman's show, scout exhibits, and tree plantings. The day ended with a ball at the Wayside Inn. Part of that celebration took place on the lawn of St. Francis Health Resort, shown here. (DHS.)

Some have questioned the authenticity of the signature that appears in the old guest register of the Denville Hotel as "Grover Cleveland, Pres." He was not president when it was signed in 1890; he was between his two nonconsecutive terms (1885–1889 and 1893–1897). However, after enlarging the image of the hotel on page 22, none other than Grover Cleveland himself (complete with top hat and mustache) emerges from the obscure figures seated on the front porch. (DHS.)

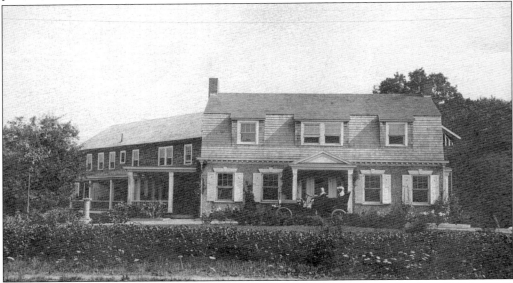

Local historian Charles M. toeLear wrote in 1988 that Pres. Warren G. Harding (1921–1923) was a guest at the Diamond Spring Inn, shown here around the time of Harding's presidency. However, in his earlier work in 1963, toeLear said that it was Pres. Herbert Hoover (1929–1933) who stayed there. Perhaps they both did. (Illig-Vialard Collection, DHS.)

The Denville Hotel burned to the ground on October 20, 1902. This photograph records the disaster, showing only the smoldering ruins of the once grand building. (Illig-Vialard Collection, DHS.)

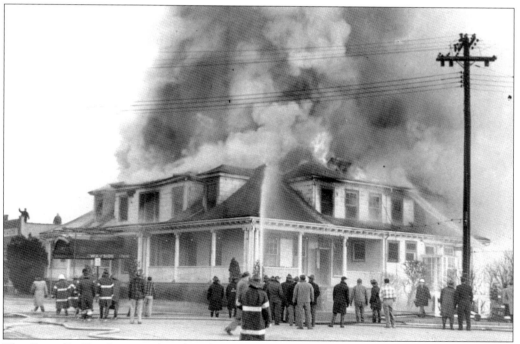

The Denville Hotel was replaced with another grand hotel, the Wayside Inn. Although the new hotel had a different appearance than its predecessor, its fate was the same. On January 19, 1953, the Wayside Inn burned to the ground. This photograph from that fateful day shows the firemen's efforts to save the doomed building. (DHS.)

Denville Fire Truck No. 2—a 1936 Dodge truck chassis, American LaFrance 500-gallon-per-minute centrifugal pumper—is on its way to a parade in 1937. Driving the truck is Adolph Foster with William Schoppman alongside him. (Illig-Vialard Collection, DHS.)

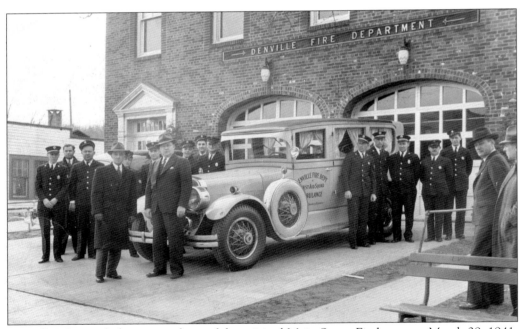

Denville's first ambulance is in front of the original Main Street Firehouse on March 29, 1941. On the left side of the ambulance, from left to right, are Charles Salle, Michael Holinko, James Beatty, committeeman Fred Crans, Bob Slater, Edward Doremus, committeeman Dr. John Gauer, James Gallagher, Albert Vialard, and James Lash. On the right side, from left to right, are Russell Lash, William Keeffe, Adelbert Doremus, Claude Mooney, Fred Heides, Art Hopler (first-aid instructor), and Ray Mathews, Esq. (Illig-Vialard Collection, DHS.)

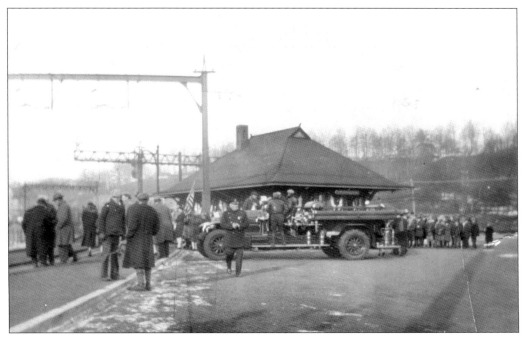

Denville celebrates the arrival of the first electric train on the Delaware, Lackawanna, & Western Railroad on January 22, 1931. The Denville railroad station is in the center. (Illig-Vialard Collection, DHS.)

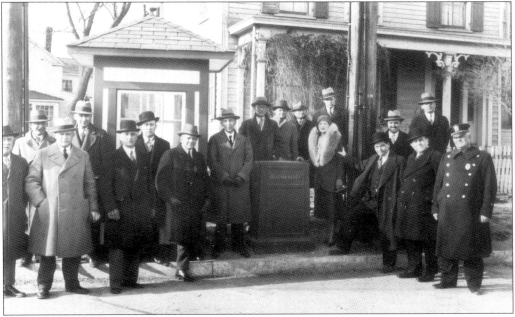

Police Chief Ben Kinsey and several other Denville officials start the traffic lights at the new Denville center on March 5, 1930. This is the corner of Diamond Spring Road and Main Street. The Marvin Dickerson House is on the right; notice the police booth to the left. (Illig-Vialard Collection, DHS.)

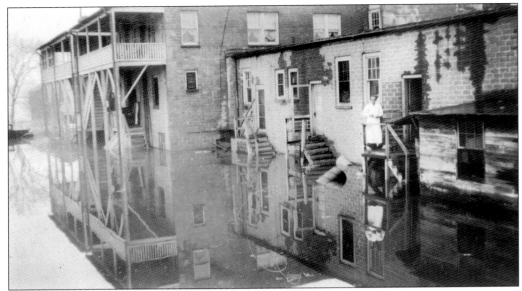

Along the back of the buildings on Main Street, store owners try to salvage what they can during the flood of 1936. (Illig-Vialard Collection, DHS.)

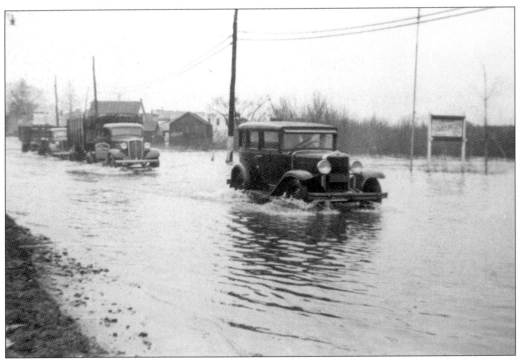

Traveling west on old Route 6 at Hinchman Avenue, the drivers of these vehicles hoped not to get stuck in the floodwaters that covered the entire downtown area. (Illig-Vialard Collection, DHS.)

126

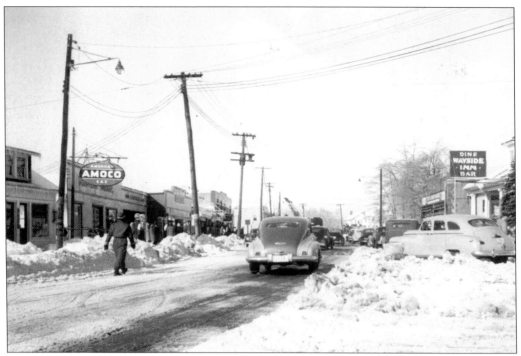

First it was the flood, and here it was the snow. Downtown Denville digs out after the Blizzard of 1947. (Illig-Vialard Collection, DHS.)

Peter Cook built the dam on his land that created Rock Ridge Lake in 1904. A developer purchased the property in 1907 and began to promote the area as a good year-round place to live. In 1919, the original Rock Ridge dam broke, causing considerable damage. In this photograph, a woman holds her head in disbelief as Fred Ahr (center, left) and James T. Barnes (center, right) help Walter H. Clarke (bending over) to repair the dam. (Illig-Vialard Collection, DHS.)

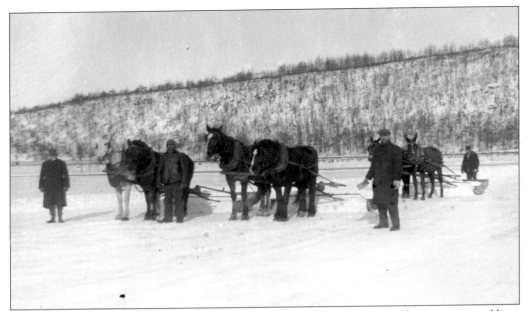

Estling Lake was built c. 1894 by the Pocono Mountain Ice Company for ice cutting. Here, Tom Lash (second from left) with horses Dart and Bill, Sam Peer (second from right), Levi Lynch (far right) with mules Dan and Jerry, and an unidentified man cut ice on Estling Lake in February 1914. Snake Hill can be seen in the background. (Illig-Vialard Collection, DHS.)

A conveyor belt collapses at the icehouses on Estling Lake. These icehouses were huge, with a storage capacity of 70,000 tons of ice. In late June 1918, the buildings were struck by lightning and burned to the ground. (Illig-Vialard Collection, DHS.)